D1451628

DATE DUE

	WITHDRAWN		
			PRINTED IN U.S.A.

the nature of
DESIGN

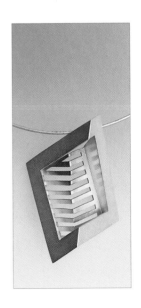

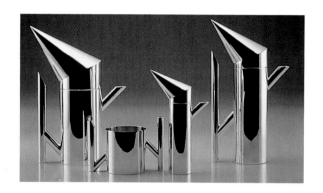

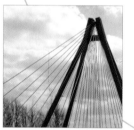

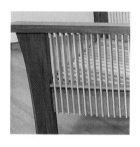

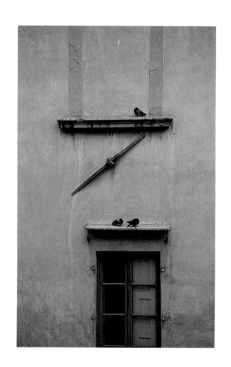

PEG FAIMON &
JOHN WEIGAND

the nature of
DESIGN

How the principles of

design shape our world—

from graphics and

architecture to interiors

and products

HOW
DESIGN
BOOKS

CINCINNATI, OH
WWW.HOWDESIGN.COM

The Nature of Design: How the Principles of Design Shape our World—from Graphics and Architecture to Interiors and Products. Copyright © 2004 by Peg Faimon and John Weigand. Bound and printed in Singapore. All rights reserved. No other part of this book may be reproduced in any form or by an electronic or mechanical means including information storage and retrieval systems without permission in writing form the publisher, except by a reviewer, who may quote brief passages in a review. Published by HOW Design Books, an imprint of F&W Publications, Inc., 4700 East Galbraith Road, Cincinnati, Ohio 45236. 800.289.0963. First edition.

Visit www.howdesign.com for information on more resources for graphic designers, architects, interior designers, etc. Other fine HOW Design Books are available from your local bookstore, art supply store or direct from the publisher.

08 07 06 05 04 1 2 3 4 5

Library of Congress Cataloging-in-Publication Data
Faimon, Peg
 The nature of design : how the principles of design shape our world—from graphics and architecture to interiors and products / Peg Faimon & John Weigand. —1st ed.
 p. cm.
 Includes bibliographical references and index.
 ISBN 1-58180-478-4 (alk. paper)
 1. Design. I. Weigand, John II. Title.
NK1510.F29 2004
 745.4—dc22

 2003056673

Editor: Clare Warmke
Cover and Interior Design: Peg Faimon
Creative Consultant: Lisa Buchanan
Production Coordinator: Sara Dumford
Photographer: Christine Polomsky

The permissions on page 194 constitute an extension of this copyright page.

About the Authors

Peg Faimon received a BFA from Indiana University and an MFA from Yale University. She has worked as a graphic designer for corporate and small design firm offices. She is currently a professor of graphic design at Miami University, Oxford, Ohio. In addition to teaching, she maintains a design consultancy. She has received national and international recognition for her professional work. Faimon is also the author of *Design Alliance: Uniting Print and Web Design to Create a Total Brand Presence,* published by HOW Design Books in 2003.

John Weigand is a professor of architecture and interior design at Miami University, Oxford, Ohio, where he currently serves as Program Director in Interior Design. After earning degrees at Miami University and at the University of Illinois, Weigand practiced for several years in Chicago prior to joining the faculty at Miami. Along with Professor Faimon, he teaches multidisciplinary design studios at both the beginning and upper levels, and he is an active participant in national-level dialogue exploring enhanced collaboration among allied design disciplines.

Dedication

To Don, Anna and Noah, for all your love and support.

–P.

Also to Ann, Kevin and Claire, and to my parents...
many thanks!

–J.

Acknowledgments

Thanks to everyone at HOW Design Books for giving us this unique opportunity. Special thanks go to two women at HOW who have shared their knowledge and experience: Clare Warmke, acquisitions editor, for invaluable guidance and expertise; and Lisa Buchanan, art director, for thoughtful design advice and great production tips. Amy Schell, Clare Finney, Richard Hunt, Phil Sexton and Christine Polomsky have also been very helpful through specific aspects of this process.

We would also like to thank our many contributors for the use of their wonderful images. Special thanks go to major contributors: Alessi S.p.a.; Jinbae Park; John Reynolds; April Greiman; Hedrich Blessing, Ltd.; Susan Ewing; Paul Owens; Zdenek Ziegler; Visual Marketing Associates; Phyllis Borcherding and the University of Cincinnati Fashion Design Program; and our many students in the Miami University Department of Architecture and Interior Design, and the Department of Art.

At our home base of Miami University, we would like to thank all those who have supported us in this endeavor, especially Pamela Fox, Dean, School of Fine Arts; Robert Benson, Chair, Department of Architecture and Interior Design; Jerry Morris, Chair, Department of Art; Sara Butler, Associate Dean, School of Fine Arts; and MCIS photography.

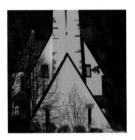

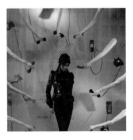

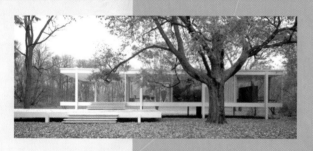

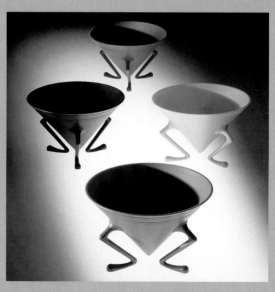

TABLE OF CONTENTS

1

Design: *To conceive and plan out in the mind; to have as a purpose; to devise for a specific function or problem; an underlying scheme that governs functioning, developing or unfolding.*

introduction

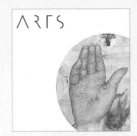

Each day, no matter where we turn, we are confronted with examples of things that have been designed: the chair we sit on, the clothes we wear, the magazines we read, the car we drive, the house we live in, and the street we live on. Even a leaf on a tree or the wing of a butterfly display not only beauty but design intent.

The qualities of design that make an object beautiful (or less than beautiful) transcend it; they pertain to all things. There are evident, identifiable principles that make us like or dislike something, even though we may not understand them. These principles, which guide the creation of the chair as well as the butterfly wing, work in concert to provide a framework for good design.

We may choose to consciously study these principles, or to absorb them gradually as we learn to more clearly see the world around us. Either way, these principles can be learned, and they can be taught. The gifted designer understands them well. They become second nature. All too often we assign this ability to intuition, or to instinct, or to a greater level of natural talent—and perhaps this is valid. But a facility in design can also be learned. The master and the novice alike can continue to grow in their understanding of design by making a conscious effort to learn and to observe.

Collectively, we in the western world have done a poor job of educating ourselves about the fundamentals of design. Design education at the primary and secondary levels, where arguably it is the most needed, is largely

"The words graphic designer, architect, or industrial designer stick in my throat, giving me a sense of limitation, of specialization within the specialty, of a relationship to society and form itself that is unsatisfactory and incomplete. This inadequate set of terms to describe an active life reveals only partially the still undefined nature of **the designer.**"

—Alvin Lustig

non-existent. At the college level (should the student choose a major in the visual arts) the effort is usually better. Even then, the student often must rely on his or her intuition to solve a problem, receiving feedback only when the work is complete. Even though learning to communicate visually and to interpret visually are not emphasized in our society, the authors believe that these skills are as important as the verbal skills of reading and writing.

Design principles cannot be described with the same kind of scientific exactness as can the principles of physics or mathematics or economics. Simply put, they cannot be neatly categorized, and they are not inflexible. Often, one or more principles are challenged, twisted, or reinterpreted by the designer to great effect. This would seem to make the principles less absolute, more subject to interpretation. And yet, the framework—the set of principles seen in total—remains.

As teachers (and students) of design, the authors have observed what we believe are several shortcomings in design education. These shortcomings have led to the identification of various objectives for the organization of this book.

First, this book makes a conscious attempt to illustrate principles across multiple design disciplines. Generally, principles which pertain to the graphic designer also pertain to the architect, the industrial designer, the interior designer, the fashion designer, and the landscape designer—yet we so often teach within our own discipline-specific bubbles. Curricula have also tended to separate two-dimensional skills from three-dimensional skills, when there is in fact a great deal of overlap. Only by illustrating the universality of design principles can we start to make connections—can we begin to see the world as a complex web of interrelated design decisions.

Second, this book provides a comprehensive identification of design principles, in a way that is clear and succinct. Precisely because design principles are not an absolute science, because they can be challenged and turned upside-down by the designer, it is usually easier to avoid trying to identify them in any concrete way. Several introductory primers in design define not the principles but the elements of design, providing the reader with a working knowledge of the language but not the principles necessary for design execution. We believe this is a missed opportunity. Even though a specific identification of design principles may appear didactic, it creates a framework for debate and, ultimately, a clearer understanding of design: a jumping-off point. Several of the principles described herein can and should be challenged by the reader. If they are, so much the better. In several instances, the photographs and text have been constructed specifically to provoke this kind of challenge. The more thoughtful questioning that takes place, the more learning will occur.

Third, the format for this book is simple and graphic. So much of what is written about design fundamentals is excessively wordy and pedantic. If the underlying principles are there, the reader must work too hard to discover them. Designers are essentially visual thinkers; it only makes sense that a treatise on design principles be, for the most part, visual and graphic. We have made a concerted effort to reduce what can be said in many words to a few words, and what can be said in few words to a visual image.

Fourth, we have illustrated design principles by showing examples of less successful—as well as successful—design solutions. Oftentimes the example which ignores a certain design principle is more instructive than that which obeys it. For comparison sake, in many of these cases, we have computer-altered photographs to change the original design to one which is more or less successful. These modifications are intended to be instructional and are clearly identified.

The authors understand that in the hands of an educated designer, the design principles discussed can be manipulated with wonderful results. For this reason, the final chapter within the Principles section, Meaning, includes examples of such "manipulations."

Finally, rather than allowing the principles to remain in the abstract, it is important that we show their application through case-study examples. It is our intent that these "design stories" demonstrate the synthesis and collaboration of the principles, resulting in a complex and holistic design process.

This book is written for anyone who wishes to hone his or her skills in design or who wishes to learn to see the world through more perceptive lenses. Read the words carefully, and study the images even more carefully. Challenge both. Our sincere hope is that this book helps in some way to raise your design consciousness and your design appreciation. Enjoy! —p&j

2 elements

Element: *A distinct part, one of the parts that makes up a complex whole, one of the factors determining the outcome of a process.*

A plan for arranging
elements in such a way
as to best accomplish
a particular purpose.

—Charles Eames

Elements are defined as the visual ingredients in any piece of art—in architecture, in interior, industrial, graphic, furniture, landscape or fashion design. Curved line, straight line, shape and volume, together with color, light, value, materials and texture are utilized in various quantities to create a design. Elements are different from principles, which are discussed in the next section. Principles provide direction in the assembly of elements. They instruct us in the "how to." If elements are the list of ingredients (two curves, five straight lines, one shape, a pinch of red), then principles guide their combination into problem-solving solutions (mix together two curves and one shape; blend until balanced and well-proportioned; add contrast through color and value; add lines to create rhythm). When the ingredients are skillfully combined, we produce something wonderful: we produce *design*.

Let's begin with a line...

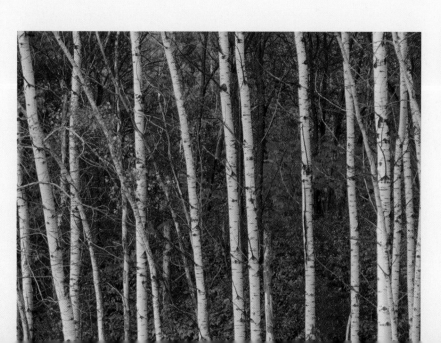

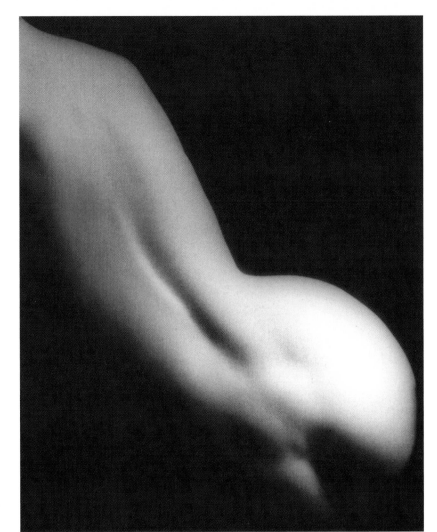

a simple curved line.

In any image that we find beauty, often the subject
of that image matters less than its composition.

What matters is the *curve***.**

If we look carefully, we find
the curve in the

*natural
environment…*

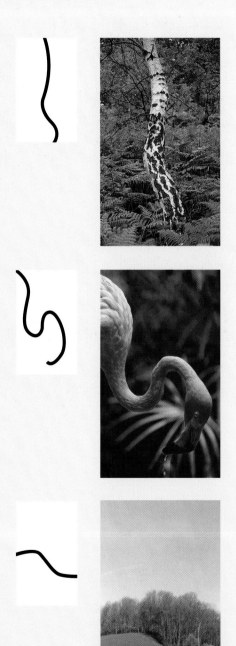

and in the

*designed
environment.*

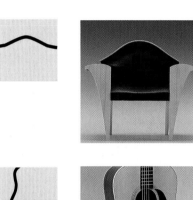

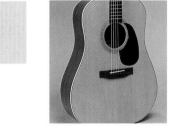

ELEMENTS

A simple curve—in fact a

single curve—

may appear in many different places

and at many different scales.

Again, it is less important
what is being designed:
a building interior, a logo
or a pin.

What matters is the

curve.

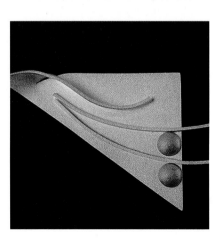

For the designer, it is important to learn how to make the curve. The number of beautiful curves is infinite.

But not all curves are beautiful! If its parts are inconsistent or poorly connected—if they fail to contribute to the whole—the curve fails.

Of course, the world is made up of more than curved lines.

There are

straight lines…

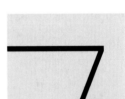

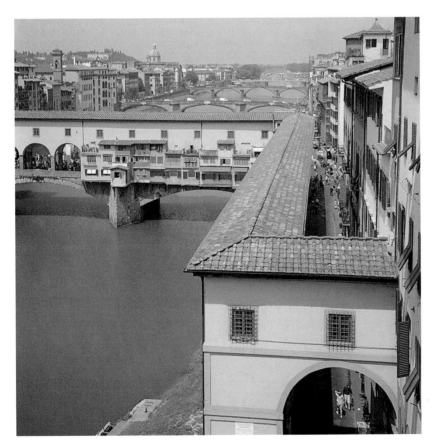

which together with the curve define

shapes.

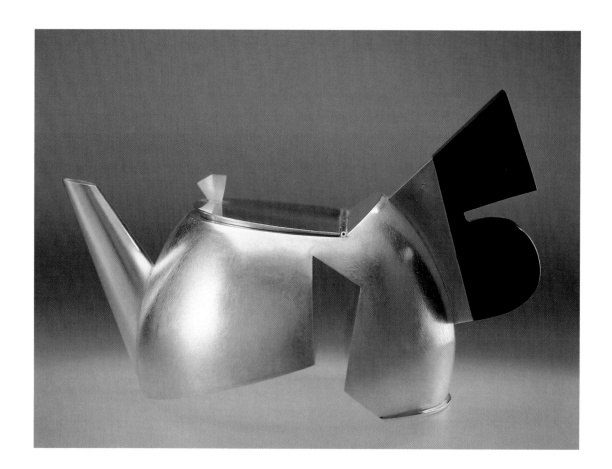

Other elements in the designer's palette include

color…

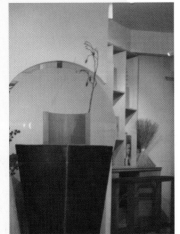

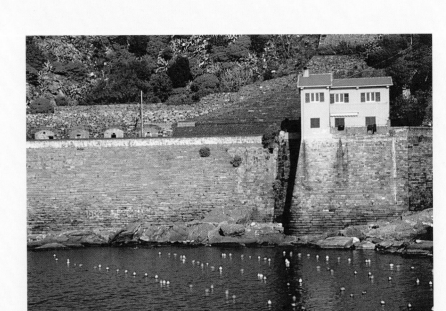

light…

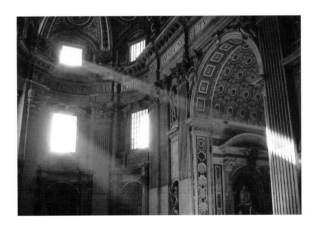

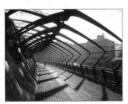

Blend it in

and *materials* or *media.*

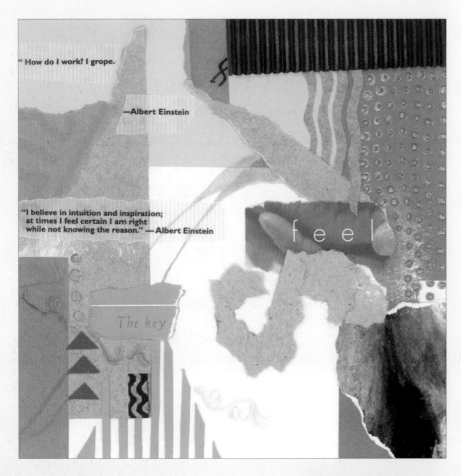

" How do I work? I grope.

—Albert Einstein

"I believe in intuition and inspiration; at times I feel certain I am right while not knowing the reason." — Albert Einstein

f e e l

The key

Most of what we see is
really a combination of
all of these. An image
can be abstracted to
line and shape.

When we add…

value…

color…

and *texture*

we have our

visual world.

The challenge to the designer is to assemble this kit of parts—these ingredients—into a pleasing, coherent whole. In the hands of the skilled designer…

the whole can be greater than the sum of its parts.

Which brings us to the purpose of this book: to present a framework for a better understanding of our visual world—and design.

So then, how do we make the curve?

3

principles

Principle: *A comprehensive and fundamental law, doctrine, or assumption; a fact of nature underlying the working process of creation and/or design.*

I f elements constitute the parts or ingredients of design, then principles provide direction in the assembly of these parts. They instruct us in the "how to." The challenge to the designer is to solve a set of functional and aesthetic requirements ("the problem") by assembling these parts into a whole. When design is understood as that wonderful condition wherein "the whole is greater than the sum of its parts," it becomes clear that this can be realized only through an understanding and application of some basic guiding principles. Good design does not occur by happenstance and it is not purely subjective. The principles discussed in this section (unity and variety, grouping, rhythm and pattern, connection, contrast, context and scale, balance, placement, proportion and meaning) are interconnected with one another. And they are not inflexible. In the same sense that we posit them as true, we also suggest that they can be interpreted in exciting ways in the hands of the skilled and educated designer.

"Every animal leaves traces of what it was; man alone leaves traces of what he has created."

—Jacob Bronowski

3.1

Unity: *The quality or charac-*

ter of a whole made up of

intimately associated elements

or parts; sameness.

Variety: *The quality or state*

of having different forms or

types, something differing

from others of the same gener-

al kind; absence of monotony

or sameness.

unity&
variety

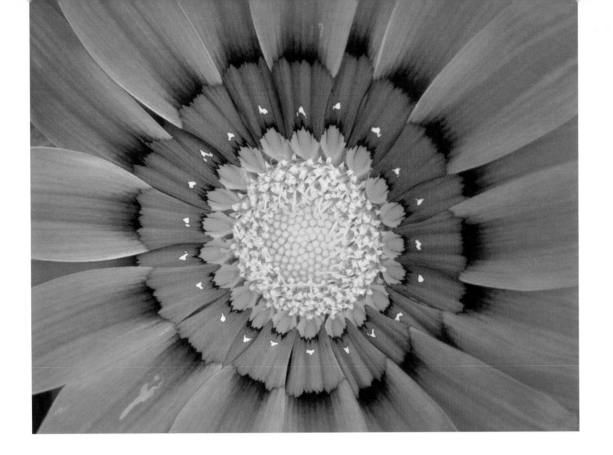

An essential quality of good design is something we call "unity-variety balance." Skilled designers understand the need to achieve both unity and variety in their work. Look closely at how *design* is defined:

to conceive and plan out in the mind; to have as a purpose; to devise for a specific function or problem; an underlying scheme that governs functioning, developing, or unfolding.

Design implies a plan, a conscious intent.

When an image becomes too complex, whether by intention or by accident—when

*t*Oo Mu**c**h Va𝓇ie𝓉y

becomes visually chaotic—the image ceases to be "designed." Simply put, *design* implies some amount of control or order. This we call *unity*.

We live in a culture where the one who shouts the loudest gets the most attention. It's not in the vulgar, it's not in the shock that one finds art. And it's not in the excessively beautiful. It's in between; **it's in nuance.**

—Duane Michaels

Excessive variety is all around us and is
characterized by many different parts
which all scream out for our attention.

Usually it results from a lack of design,
or from having

*"too many ~~cooks~~ ^{designers}
in the kitchen."*

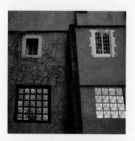

Sometimes excessive variety is intentional…

don't decorate.

Too much variety—too many different parts—can
convey a lack of control. No matter how beautiful
the parts, they do not necessarily combine to create
beautiful design.

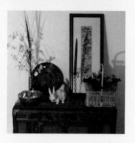

On the other hand, good design should have visual interest and variety. Too much

sameness is boring.

**ED & BOB'S
PET SUPPLY
12 S. HIGH ST.
OXFORD, OH
800-555-0066**

Excessive unity is often the pitfall of the beginning designer who, in an effort to keep control over the design, limits the visual palette too much. We would suggest that the best design is actually varied and subtly complex; it does not reduce the problem to its simplest terms, yet it remains controlled.

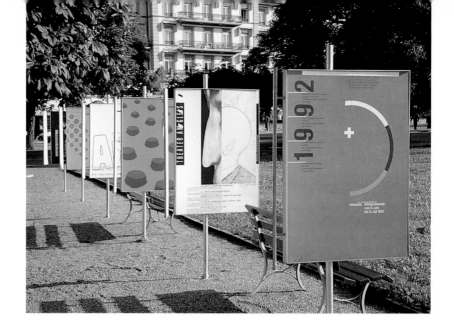

In the image above, the environmental designer creates unity by controlling poster size, spacing and display. Variety is created in each individual poster.

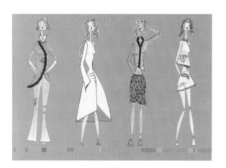

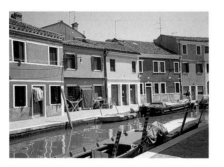

The images above carefully balance like and dis-similar elements. In the fashion sketches, top, the four outfits are quite distinct, yet, through color, pattern, accents, and overall shape, they become a unified clothing line. In the row of houses, above, color brings playful variety to buildings of similar size and style.

Good design displays both unity and variety.

The parts clearly belong to and strengthen the whole. They are both alike and different from each other. Yet they belong together in a way that shows a conscious intent. This is the very nature of design—it is not arbitrary.

The amount of variety or unity is often determined by the functional requirements of the problem.

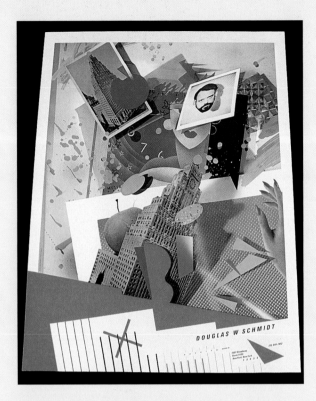

These two examples clearly display complexity. Yet the designers control this complexity through a more subtle unification of parts. Design decisions are not random.

DOUGLAS W SCHMIDT

The more complex a design, the more underlying order there needs to be—a plan for the complexity.

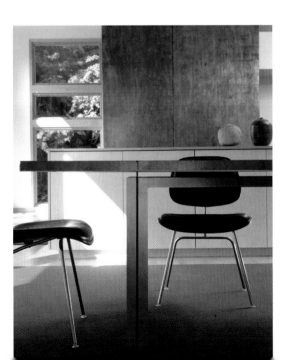

A simpler design can still have great "interest," especially in the details.

Let's look at some examples:

In this poster, the designer can vary typeface choice and size, color, and placement of words and images. The solution on the left is excessively unified and lacks interest. On the right, variety becomes excessive. Letter sizes, styles, colors and placement are so varied that design decisions appear random, even chaotic.

Somewhere in the middle is an appropriate solution and a successful design.

In this example, the designer can vary window sizes, shapes, placement, and material selections. The solution on the left is monotonous. Yet when too much is varied, as in the solution on the right, the designer loses control.

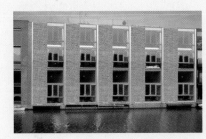 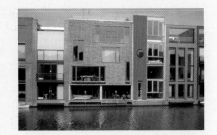

Again, somewhere in the middle lies a more appropriate solution.

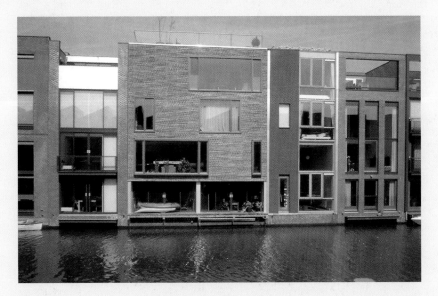

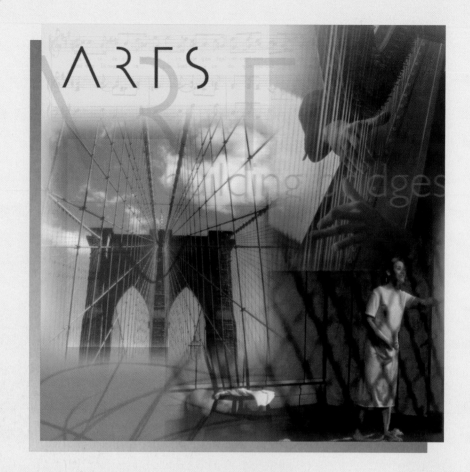

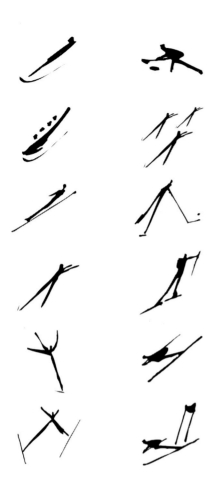

The "middle" between unity and variety is especially important when working in a series or sequence.

The magazine pages opposite, the Olympic symbol system above, and the image collage series right, all show examples of unity-variety balance. In each case unity is important to maintain consistency of visual communication, but there is also a need to handle differing visual and written content through variety.

It's all about finding balance.

The extremes—too much variety or too much unity—usually can be spotted and avoided. Finding the appropriate place in the middle is the bigger challenge.

How, then, can we begin to bring unity or order to design?

■▲●

3.2

Grouping: *The act or process of combining in groups; a set of objects or images combined into a group; the organization of parts into a whole.*

grouping

A clear organization of parts conveys order, or intent. When the assemblage of parts becomes random, or when we focus only on the parts and pieces and not on how they relate to each other, the design suffers. We help to unify a design by consciously grouping parts together. Strategies for grouping include...

"What the creative act means is the unfolding of the human psyche in the sudden realization that one has taken a lot of disconnected pieces and found...a way of
putting them together."

—George Nelson

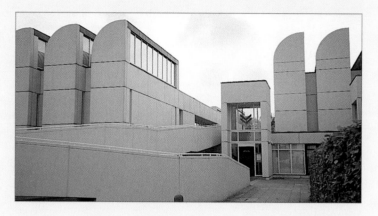

...the use of

like parts.

The human eye will naturally seek to group together like parts, as opposed to unlike parts. The organization of parts into a grouping needs to be thoughtful, not random, so the viewer can clearly "read" the intent of the designer.

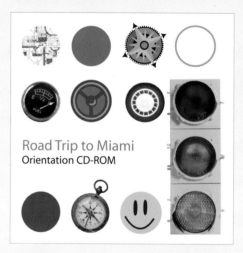

Road Trip to Miami
Orientation CD-ROM

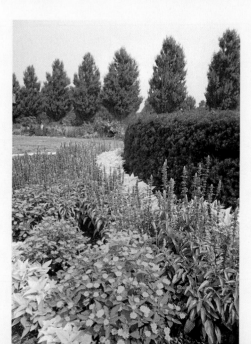

The grouping of like parts is illustrated abstractly in the black and white inset diagrams.

...the repetition of

common elements.

This can include the repetition of shapes, lines, curves, colors, angles and sizes.

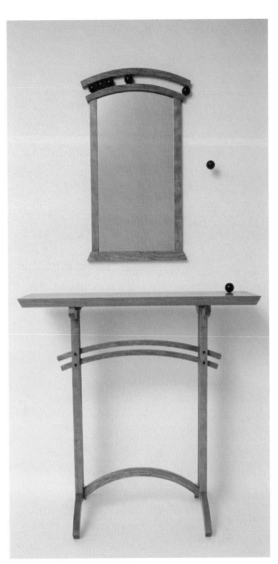

The mirror and table are grouped, or unified, into a single design through repetition of the curve, repetition of material, and repetitive use of the black balls.

abcdefghijklmn opqrstruvwxyz

Look carefully at the other examples on this page. What common elements are repeated as a way of unifying each design?

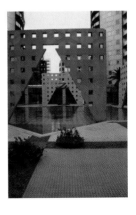

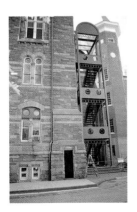

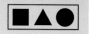

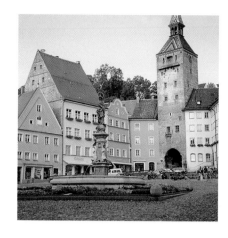

...the use of

proximity.

In the same way the eye seeks to group like parts, it also seeks to group parts in proximity to each other, whether alike or different.

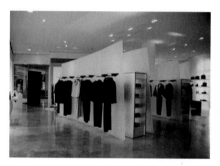

In the town center and clothing store, above, and logo, left, unity is achieved simply by placing elements near or touching one another.

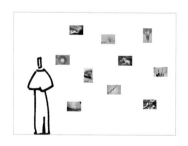 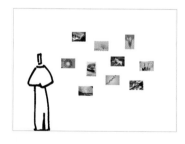 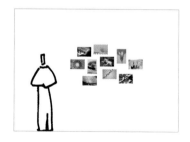

Proximity is readily apparent in this sequence. As photographs on a wall become more closely spaced relative to their size, they "read" as a single composition. At what step in the progression do we perceive the parts as grouped into a larger whole? If proximity is used as a tool for grouping parts, then we should be clear about our intent. In the first two images, the intent is fuzzy and unresolved. The intent is sharpened (and the design strengthened) in the last image.

...the use of touching or

overlapping parts.

Overlapping is really proximity taken one step further. Even very different parts, when overlapped, will "read" so strongly as a group that it becomes difficult to accentuate—or call attention to—a single part.

In these examples, we first see not one specific part, no matter how unique, but the whole of the composition.

...placing parts within a

common ground.

Even when the parts are different, or not especially
proximate, they can be grouped together by the use
of a common ground.

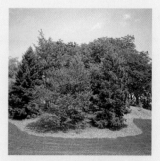

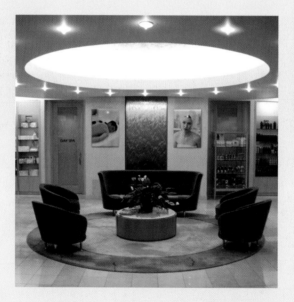

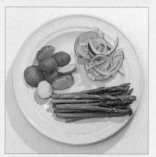

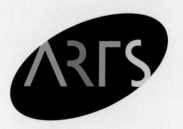

*In these examples, the mulch bed,
window framing, dinner plate, area
rug and black oval all serve as
common grounds to unify the
parts contained within.*

...placing parts within a

border.

A border (or outline) will likewise unify the composition by drawing together the elements or parts into a coherent whole.

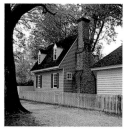

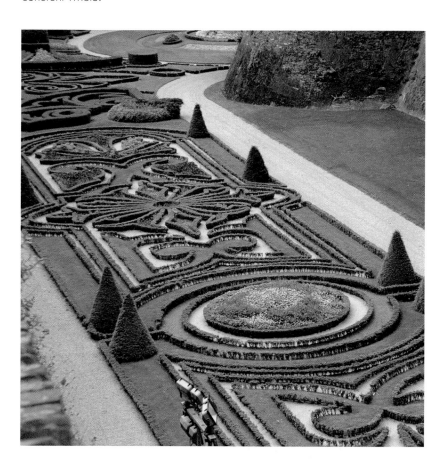

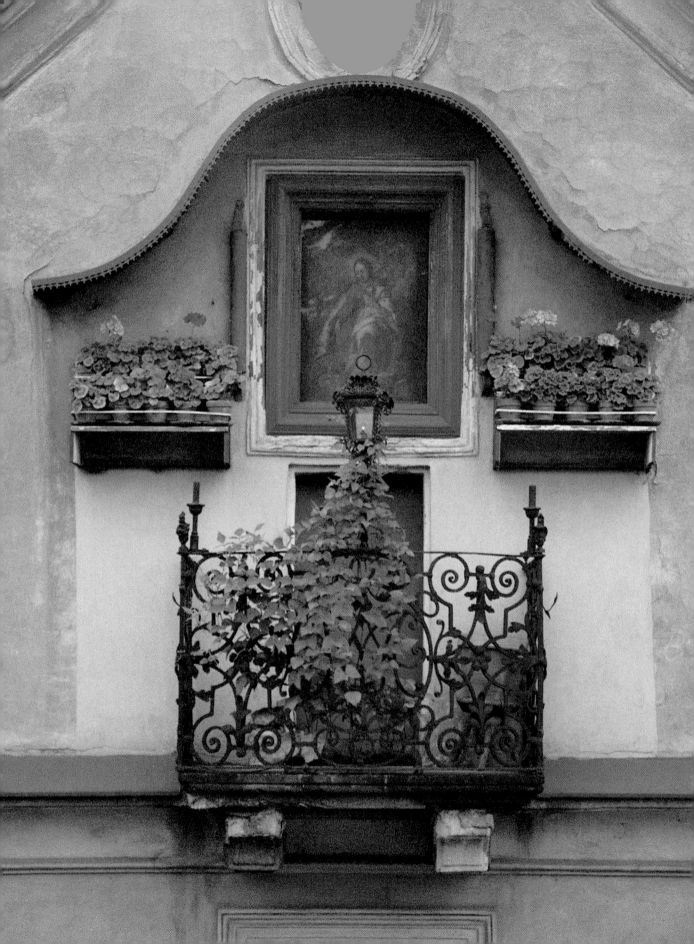

...or within a broken or

implied border.

A broken or implied border can also create a strong visual connection between parts. It can group and unify several distinct parts, without completely outlining the parts.

Using your hand, cover the curved arch element (opposite). Notice how the two planters, railing, door and window appear less unified and the design suffers.

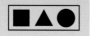

grouping

Always group parts with intent.

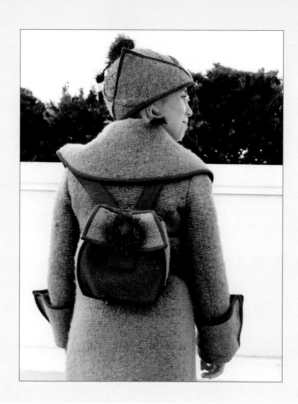

If the placement of a part is ambiguous relative to
a border or a group, it will create confusion.

A stray part can become an unintended focus, as
illustrated in these modifications of images shown
earlier (see p. 42).

If the focus is *intended* by the designer, how-
ever, it can become a powerful part of the
composition (see *focus*, p.84).

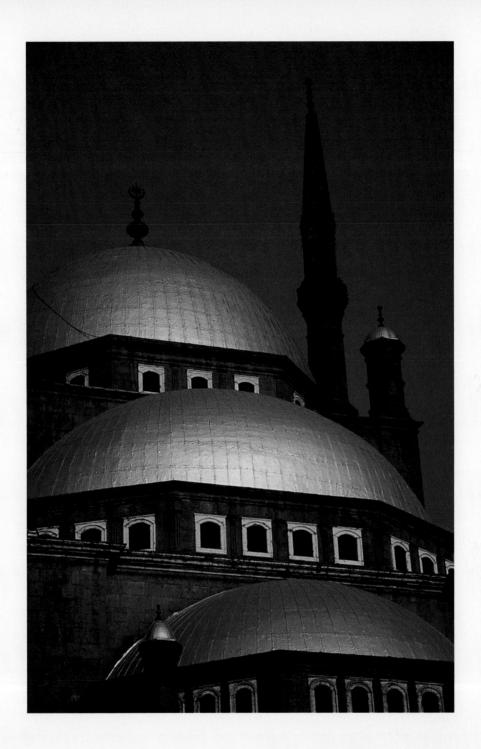

Let's look at some other ways we can
unify, or order, a design....

3.3

rhythm

Rhythm: *Movement or fluctu-*

ation marked by the regular

recurrence or natural flow of

related elements.

Pattern: *Repetition involving*

the exact duplication of a

module uniformly spaced.

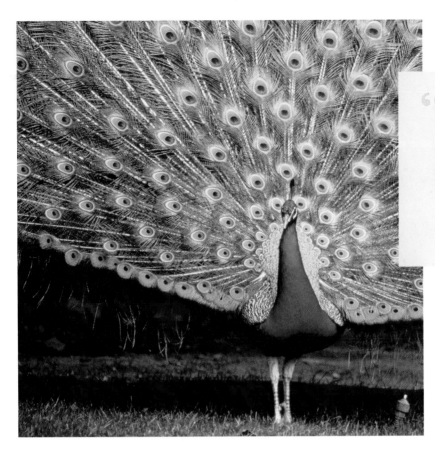

> "Echo replies to echo,
> **everything
> reverberates.**"
>
> —Georges Braque

&pattern

A powerful tool in the designer's palette for ordering a design is the use of rhythm. This is possible when the problem allows for a regular recurrence of like elements. The frequency of recurrence, whether

uniform... ■ ■ ■ ■ ■ ■

or syncopated... ■ ■■ ■ ■■ ■ ■■

must be understood by the viewer.

Pattern is related and, like rhythm, is a powerful tool for organizing design.

Look to the problem for an appropriate use of *rhythm.*

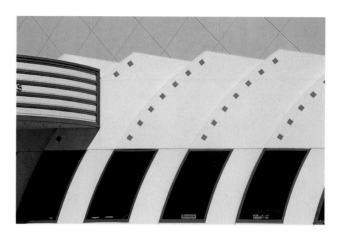

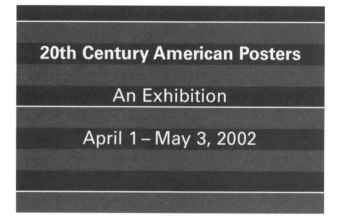

20th Century American Posters

An Exhibition

April 1 – May 3, 2002

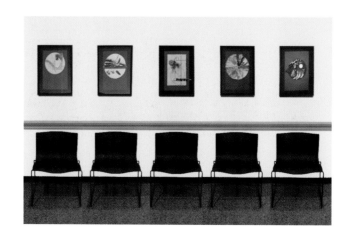

Don't force it, though; the parts must be the same
or similar, and their recurrence regular enough to
be understood.

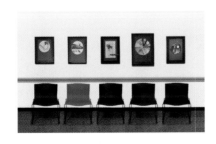
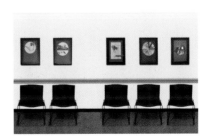

Keep in mind that several different rhythm systems may be superimposed, often to great effect.

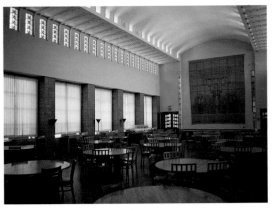

In this interior, the careful placement of small and large windows, columns, lighting, and furniture relative to each other creates a successful design solution. Similarly, the architectural façade below superimposes multiple rhythms to create visual interest and variety.

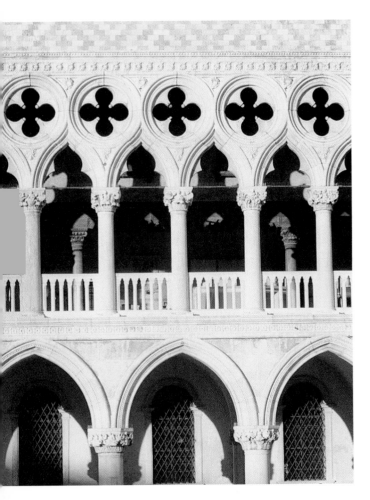

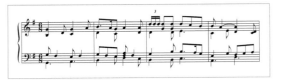

In the same way that the eye perceives visual rhythm, the ear hears superimposed rhythm in a musical score.

When using rhythm as a design strategy, however, be consistent or deviate with intent.

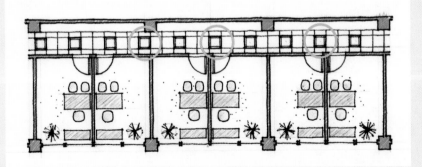

In this combined floor/ceiling plan, the rhythm of light fixtures in the hallway fights the prevalent rhythm system established by the column grid, and the placement of windows, doors and furniture. Although the light fixtures are equally spaced, their placement becomes visually jarring in places and suggests a different design solution altogether.

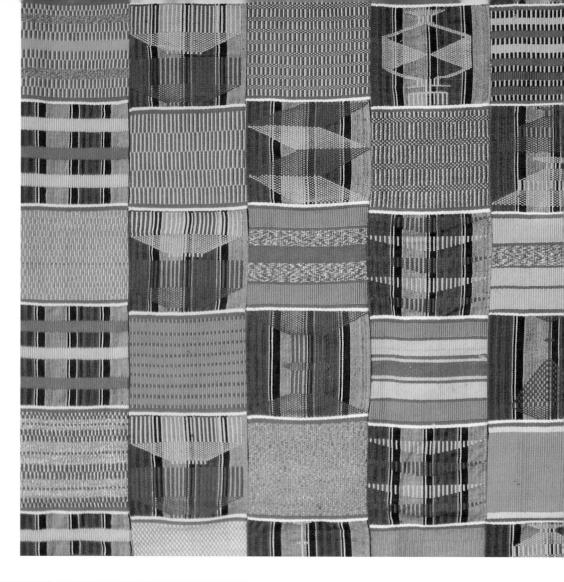

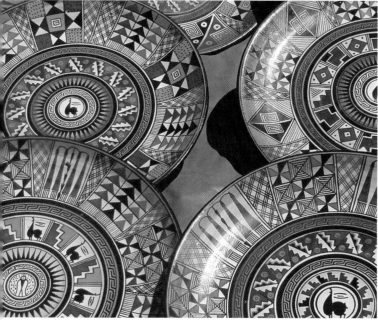

A similar grouping strategy involves the use of

pattern…

the "exact duplication of a module, uniformly
spaced."

The regularity implied by pattern allows for
more variation within the module itself. In fact,
by definition, pattern is an example of unity–
variety balance.

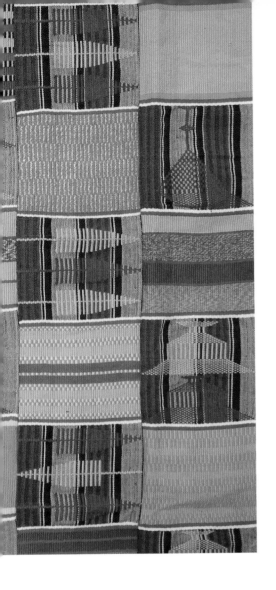

the egyptian arts

Like rhythm, pattern is a powerful organizer within the designed environment…

and, as with rhythm,
we must pay careful
attention to the likeness
of parts and to their
regular recurrence.

The experienced designer looks for opportunities to use rhythm and pattern to create interest at multiple scales. In the top right image, for example, the chair slats echo the rhythm created by the chairs themselves. Likewise, the house and church door illustrate the rich opportunity to develop visual interest at multiple scales and to explore design at the level of detail.

Remember the need for unity–variety balance at all scales and at all viewing distances.

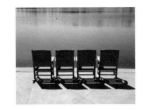

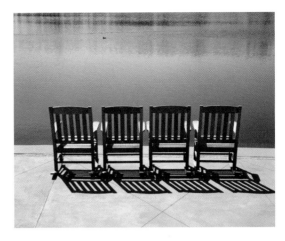

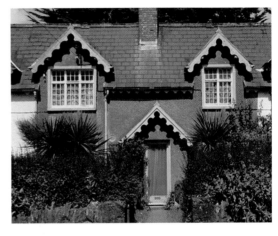

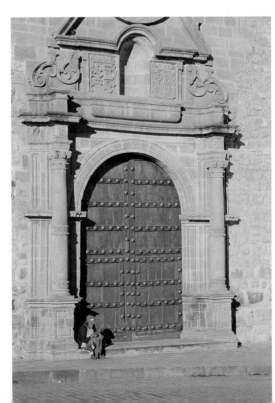

When pattern is reduced in scale to a point where its modulation is not

readily apparent, we refer to this as *texture.*

Texture can also be random.

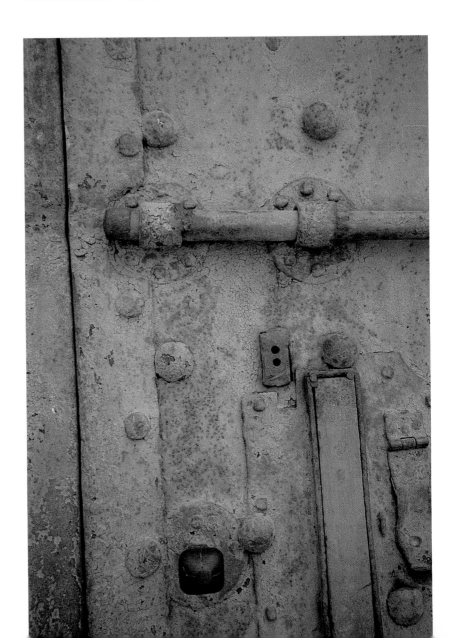

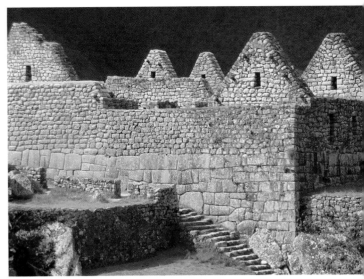

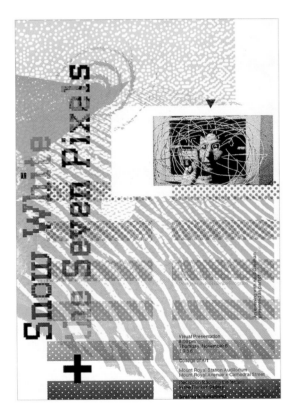

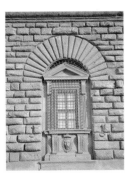

As with pattern, texture creates variety and interest in a composition, and can add to meaning and communication.

Once a rhythm or pattern is clear, it may be "punctu-
ated"—especially if the problem calls for it. Again,
remember the need for both unity and variety.
(see *focus*, p.84)

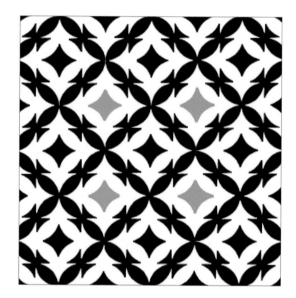

But punctuate with intent! If a change appears
random or arbitrary—or is too insignificant—it
will appear to be a mistake or "near miss."

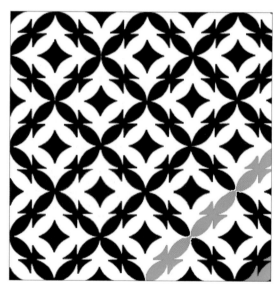

Consider repeating the punctuation to create a new pattern.

As always, be on the lookout for excessive unity, excessive variety…

and excessive pattern!

How else can we relate parts to create a cohesive whole, particularly when the parts might be very different?

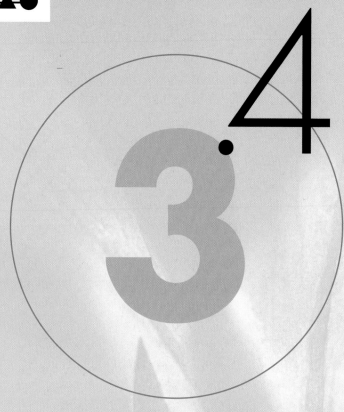

3.4

connection

Connection: *The act of connecting; the state of being connected; bridging of two like or dissimilar parts to strengthen their relationship.*

> "No house should ever be on a hill or on anything. It should be of the hill. Belonging to it. Hill and house should lie together each the happier
>
> # for the other."
>
> —Frank Lloyd Wright

When the parts are not really alike, yet must relate to each other as part of the greater whole, they can be visually or physically connected. The connector, in essence, becomes a new part, and it may connect similar as well as dissimilar parts. Often designers focus on the parts at the expense of their connection. Finding or creating beautiful parts can be easier, in fact, than figuring out how to connect them. Yet in the connections—in the details—lies the real beauty.

c
o
n
n
e
c
t
i
o
n

In order to connect two
or more parts, look close-
ly at their inherent quali-
ties: How are the parts
alike or different? And
what does this suggest
for their connection?

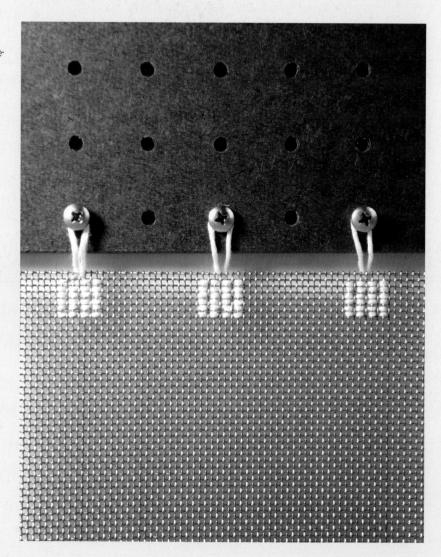

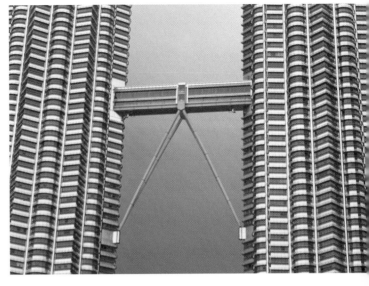

A connector may be visually

prominent…

or more

subtle.

The title and window image in the poster above, the silver balls in the earrings below, and the doorway below left, each serve to subtly connect distinct parts.

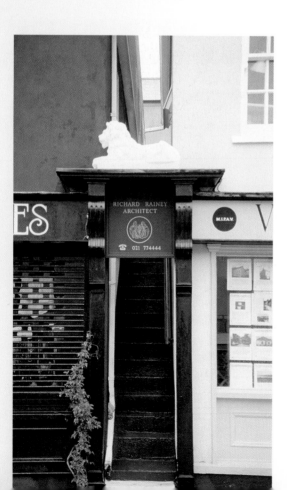

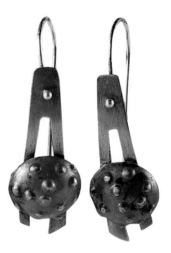

And in the same way we connect parts in a design, it is equally important to…

connect the object being designed to its environment or context.

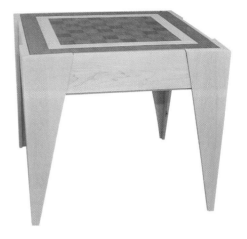

What does the portability of furniture (compared to the permanence of architecture) suggest for its connection to the ground? Why does furniture often taper as it meets the floor, while the connection of architecture to the ground is frequently more pronounced? What would our impression be if the opposite were true?

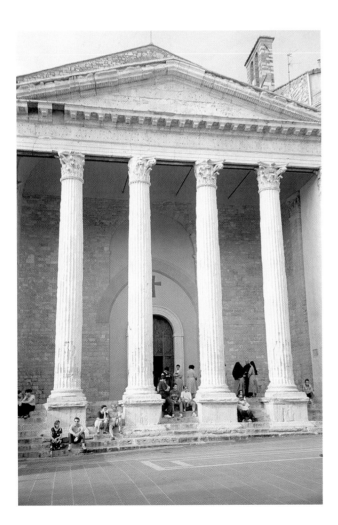

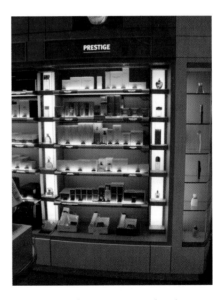

Connection to the environment is also relevant to the graphic or product designer. If the designer does not understand the environment for a point-of-sale display, for example, the design will be less successful and perhaps even ineffective (see Context & Scale, pp. 92–101).

In architectural design there is a critical connection between

inside and outside.

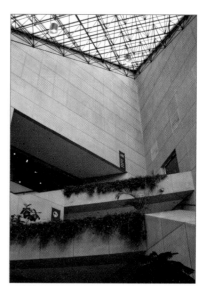

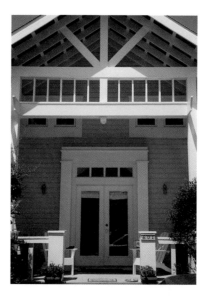

In these examples, the front porch and the atrium space allow for effective transitions between inside and outside and help to connect the two.

Connection with the earth

can evoke an emotional response.

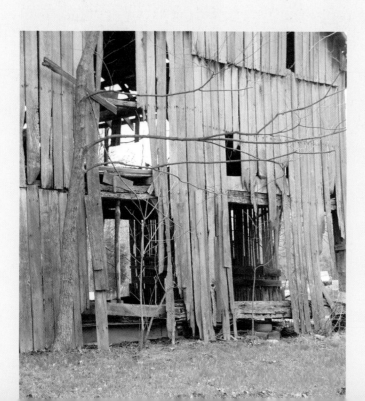

When we see an old barn, crumbling and in disrepair, our reaction isn't a negative one, but positive. The barn is charming, with a rural romanticism—"returning to the earth."

How does this image compare to the typical suburban house above, which has very little connection to the ground, as if it landed from outer space?

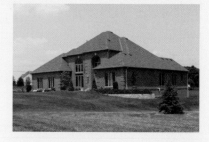

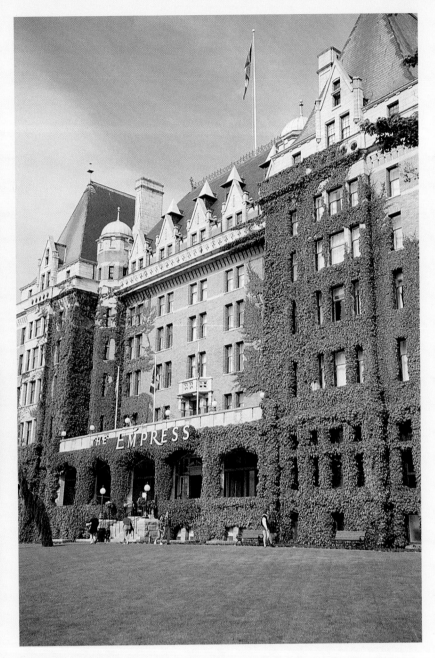

Let's look at one example more closely. As reinforced by the manipulation at top left, the ivy strongly grounds this building to its site. In the same way, as illustrated at bottom left, the building connects to the sky through its articulated roofline. Via careful consideration of connection, the parts are woven together to create the whole.

Sometimes the best connection between
distinct parts is a clearly defined

separation.

In these examples, the clear space becomes an
important element in the composition—
a breathing space.

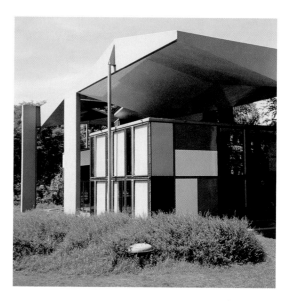

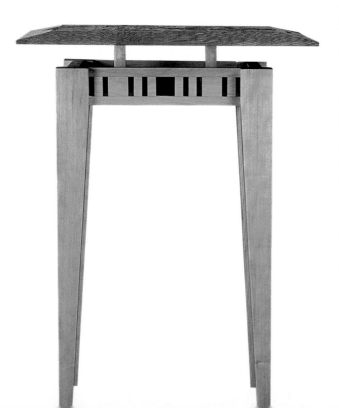

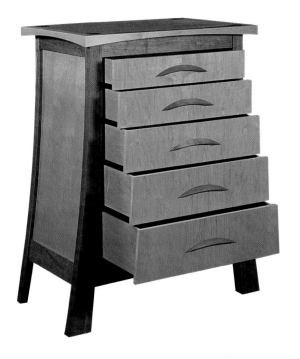

Or the connection may be a

transition…

from one element to the next, gradually
varying size, spacing, color, texture, orientation—
or several of these.

A transition will not be apparent if there are too
few steps, or if the progression is not uniform.

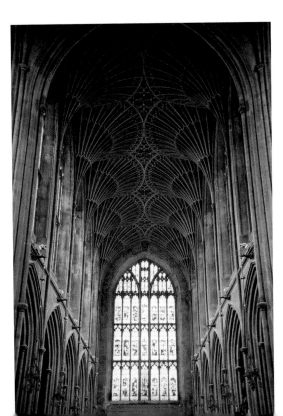

connection

Remember to provide appropriate "breathing space" between distinct parts. If the parts are to be separate, separate them with intent.

The proximity of individual letterforms, or distinct rooflines, is visually confusing. Are they intended to touch or not?

Avoid weak or unresolved connections.

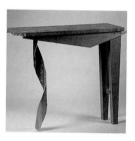 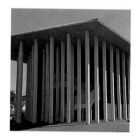

The juncture of table leg to tabletop, and of building columns to roof and ground plane, both fail to recognize the unique condition that exists at these points of connection.

Also avoid ambiguous connections.

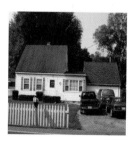 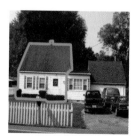

In this example, the parts and their relationship to each other are unclear. Our eye simultaneously perceives multiple connections, resulting in visual confusion.

No matter how wonderful the parts, the
design of the whole succeeds only through
careful study of their connection.

Sometimes a part is rendered more clearly
when it stands in juxtaposition to other parts....

3.5

contrast

Contrast: *A difference, especially a striking difference, between things being compared; juxta-position of dissimilar elements.*

One of the most powerful tools in the designer's kit is contrast. When an element stands in contrast to something else, it is rendered more clearly; it is more easily understood. A single element that stands out in a composition becomes the focus of the composition, a center of activity, attention, or attraction. Multiple elements in a composition that are ranked or prioritized in their visual importance display a hierarchy.

> "In contrast to the flux and muddle of life, art is clarity and enduring **presence**."
>
> —Yi-Fu Tuan

Many qualities can be contrasted:

size...

texture...

shape...

value...

color...

position...

Don't be timid.

Strong contrast

can be used to great effect.

In these examples, contrast in orientation, color,
shape and size imply design intent and create
a sense of drama.

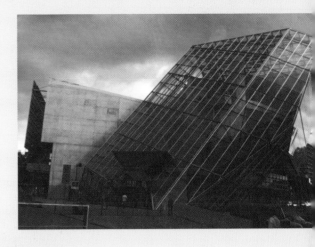

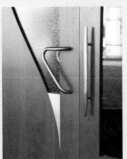

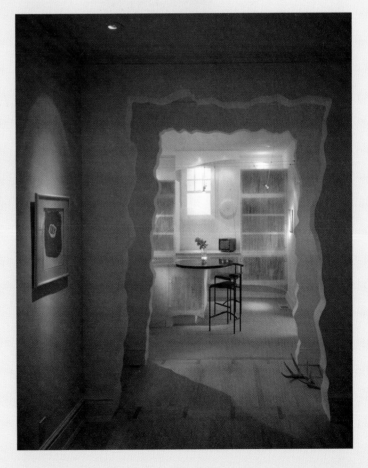

The successful designer is always conscious of this need for contrast. For example, look more closely at

color.

For all the complexities of color theory, we suggest that good color choices are made by paying careful attention to contrast...

and to providing contrast in all color's qualities:

hue…

value…

intensity…

Look again at the original example from the
previous page minus the contrast in…

hue…

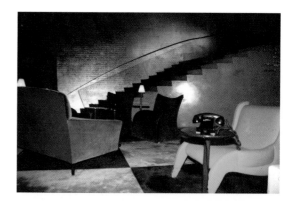

value…

intensity…

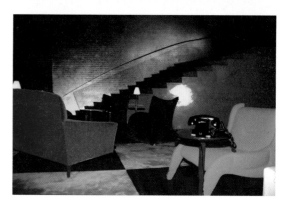

In each case, without contrast, the color appears
less resolved, less pleasing.

The eye naturally seeks balance.

In the same way, the designer should provide
contrast across the spectrum of design qualities.

Contrast through color

can be one of the designer's most effective and powerful tools. Color

can be more *prominent…*

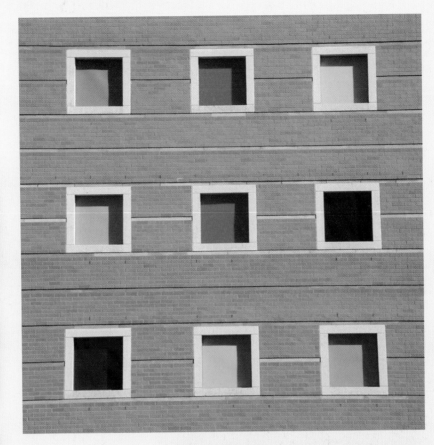

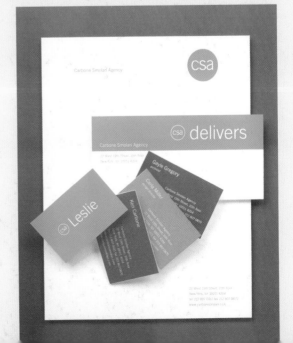

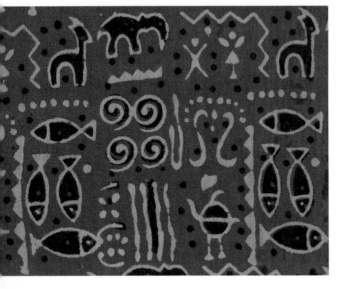

or more *subtle.*

Although we elect to discuss color relative to contrast, understand that color proportion and placement decisions are equally important. Color is all about relationships and context.

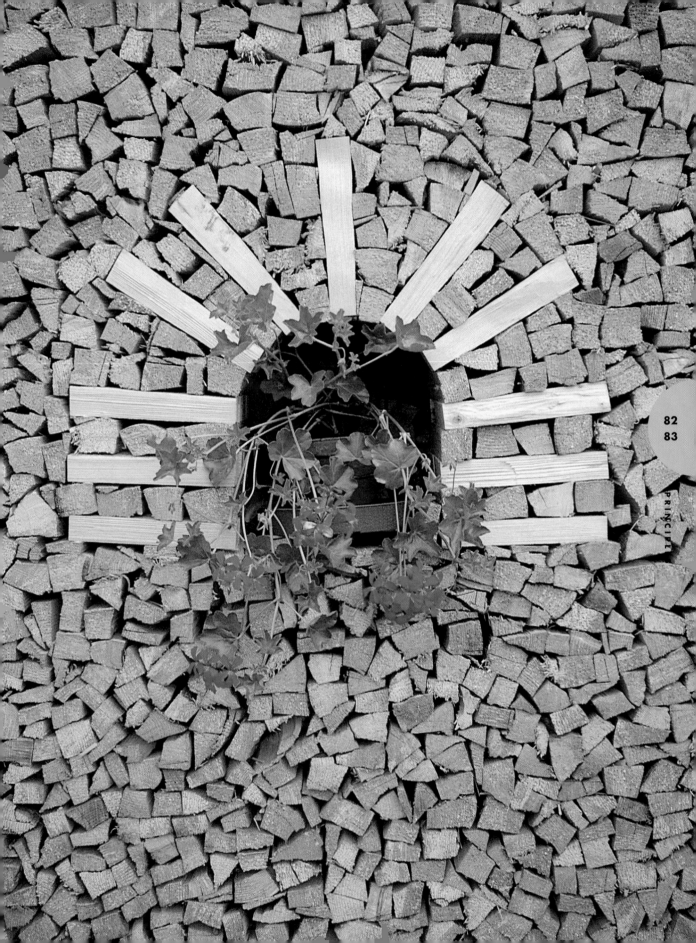

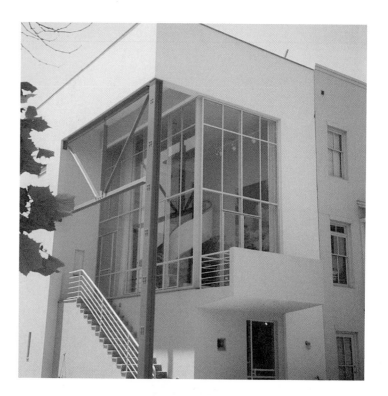

When a single element
stands out in a visual image,
we refer to this as a

focus.

Look to the problem for clues
as to what is important and
what should be emphasized.

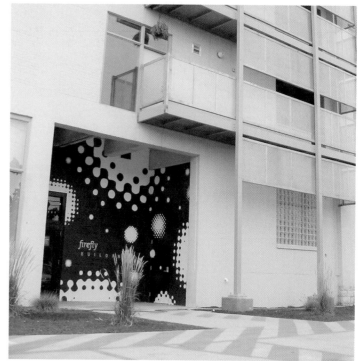

Sometimes a focus is too strong, so the eye gets stuck in one place. We believe the window in the image below succeeds as a focus. Yet when color is applied (right image), somehow the focus becomes *too* strong.

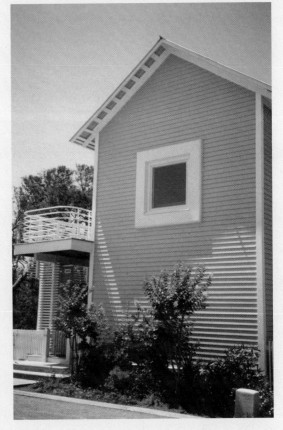

And sometimes a focus is inappropriate. If it is not called for by the problem or if it commands more attention than it deserves, it stands out as an extraneous part.

In these images, both the flamingo and garage addition detract from the clarity and simplicity of the design solution.

c o n t r a s t

The focus should be clear. Make sure different parts don't compete for attention and cause confusion.

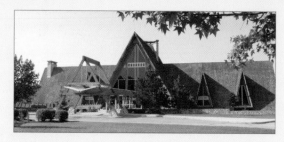

The central A-frame element of this lodge is a clear focus; yet the wings, because of their disproportionate size, compete for attention.

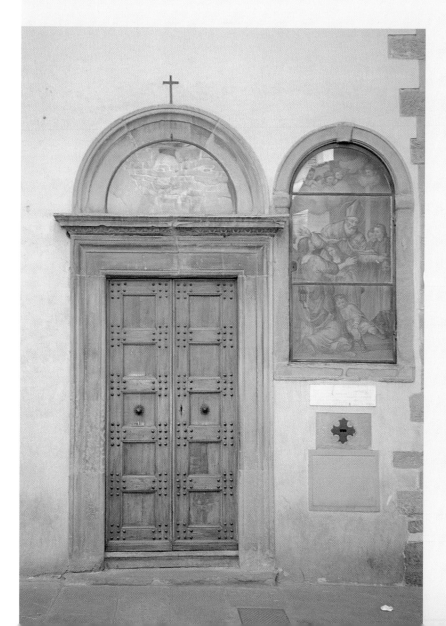

Look again at this image of a busy commercial street, in which the various parts compete strongly for the viewer's attention. It is clearly an example of competing focuses. Often, however, design is needed to sell something. A strong focus or even competing focuses might seem unavoidable.

The solution to this problem speaks to design *process* and the need for better communication among multiple designers.

Design is also improved through careful consideration of *hierarchy*.

In the images above and on the right, unity is achieved by allowing individual signs to have equal visual weight within the larger context.

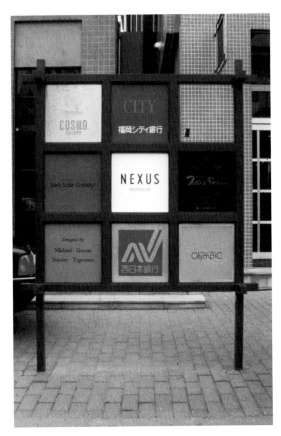

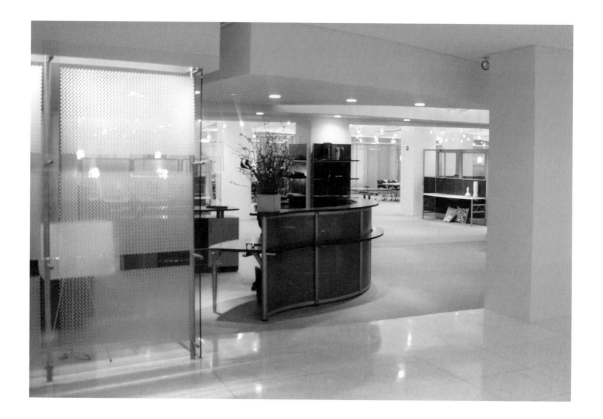

When different elements in an image are ranked in terms of their visual priority, the image displays a

hierarchy.

Hierarchy unifies a design and allows our eye to move from the most to the least important part. Hierarchical relationships will evolve through careful scrutiny of the specific requirements of the design problem.

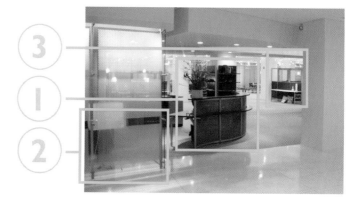

Levels of hierarchy: The reception desk attracts the primary attention of the viewer. The panels to the left are secondary and the elements in the back of the room are tertiary.

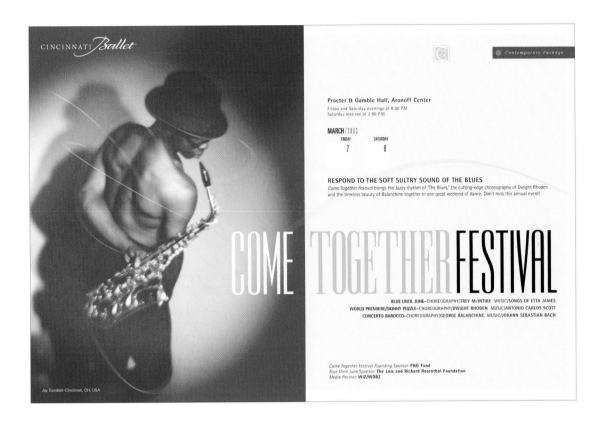

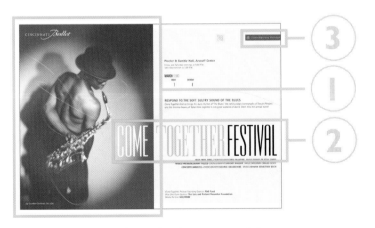

Levels of hierarchy: The photograph is the primary visual element on the page and the headline/title is secondary. The section bar at the upper right is seen third by the viewer, and the content information fourth.

through a design in a logical sequence

which allows our eyes to move

A well-designed hierarchy

is often taken for granted.

These graphics demonstrate the importance of contrast, focus and hierarchy.

through a design in a logical sequence

which allows our eyes to move

Awell-designed hierarchy

is often taken for granted.

Likewise, the poster above demonstrates that the effective use of size, placement and contrast is extremely important when setting up a clear information hierarchy.

So if the parts make up the whole, what do the wholes make?

3.6

context&scale

Context: *The interrelated*

conditions in which some-

thing exists or occurs.

Scale: *A proportion between*

two sets of dimensions.

> "Always design a thing by considering it in its next **larger context.** A chair in a room, a room in a house, a house in an environment, an environment in a city plan."
>
> —Eliel Saarinen

One of the most fundamental principles of good design is that it exists across scale and across discipline. No design problem exists in isolation. It is, by definition, a whole consisting of parts, and a part of a larger whole. It exists within a *context*. This principle challenges the very process of realizing design and suggests better ways of working collaboratively and across discipline. Consider…

unity within variety (within unity)…

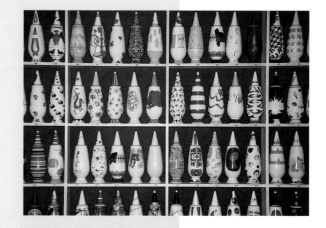

grouping within grouping…

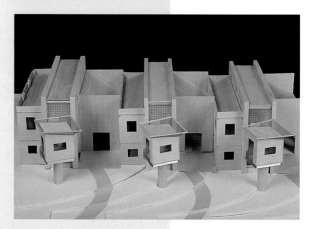

rhythm within rhythm.

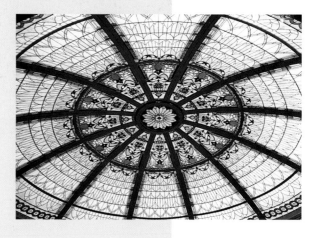

All too often, designers choose to solve a problem at one scale only, while ignoring

the larger context.

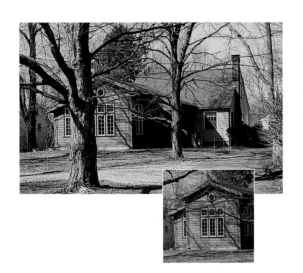

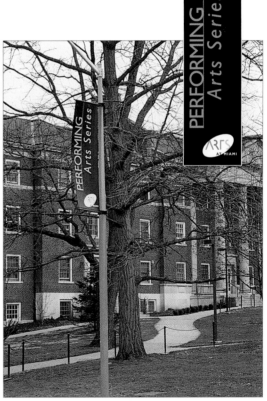

In isolation, both the house addition at left, and the banner above are thoughtfully designed. Yet, in context, neither works as effectively. The addition does not have enough common elements to group it with the house, and the banner's dark value blends with the environment instead of standing out as intended.

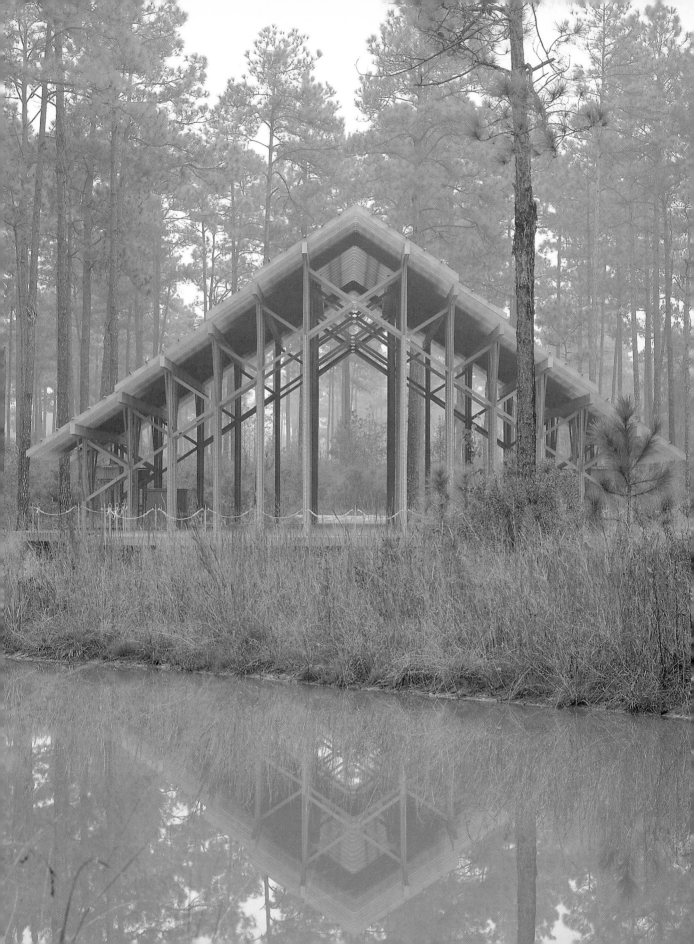

An understated design—one which
blends with its surroundings—is often

appropriate…

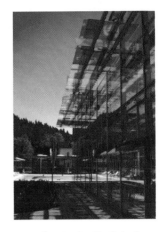

*The pavilion, opposite, clearly draws inspiration from its site. Similarly, the
building interior, above, has a clear and logical relationship to its exterior.*

and often it's not…

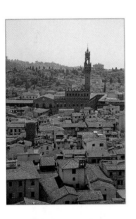

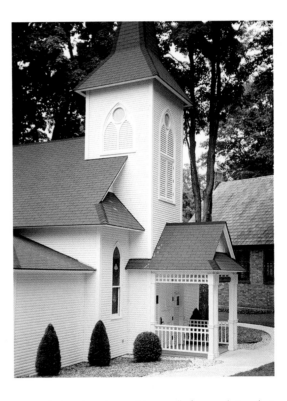

*Prominent city buildings,
such as a town hall, top, or a
church, right, call for a strong
visual presence in the urban
landscape. The retail display,
above, because of its more
temporary nature and its
need to market products, is
also an appropriately promi-
nent solution.*

particularly when the problem calls for a solution that
is visually prominent, or possibly more temporary.

*Look closely to the
problem for clues.*

Sometimes an overstated design is just that: *overstated*. Good design need not call attention to itself in order to be good.

Good design is not about ego.

Good design is scaled appropriately to the eye.

Design for the human scale. Be aware of the viewing distance, whether the design will be seen from afar or held in the hand.

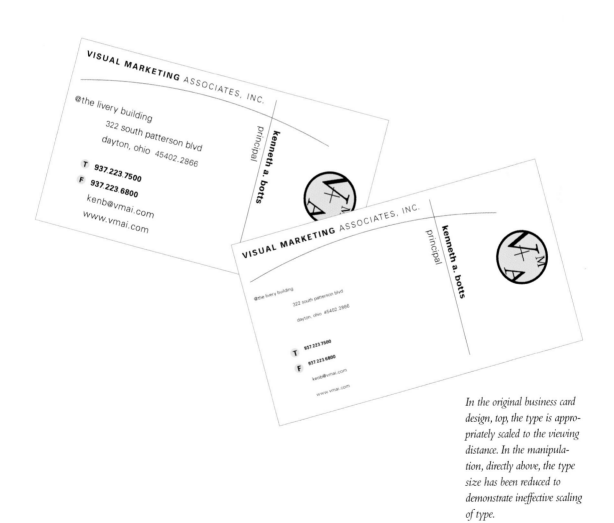

In the original business card design, top, the type is appropriately scaled to the viewing distance. In the manipulation, directly above, the type size has been reduced to demonstrate ineffective scaling of type.

*Good design is also
scaled to the body.*

The eye and the body will sense
when something is out of scale.

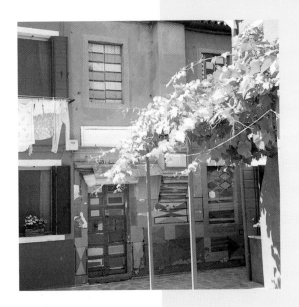

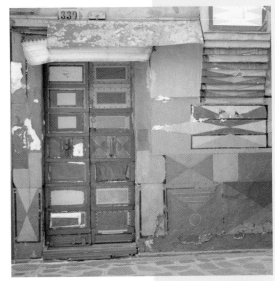

Most importantly, remember that design is appreciated and understood at many scales. It is therefore the responsibility of the designer to…

engage the problem at all scales.

Next we look at visual balance.
Where do we position the parts?

3.7

balance

Balance: *Equipoise*

between contrasting,

opposing, or interacting

elements; an aestheti-

cally pleasing integra-

tion of elements.

In the same way the eye seeks balance through contrast, the eye also seeks balance within a visual field. This balance may be symmetrical or asymmetrical and is created through a variety of design strategies. It is important that the designer consider balance as occurring in both two and three dimensions.

When compositional elements are not balanced around a visual axis or centerline, the effect can be jarring.

One way of creating balance

is through the use of

symmetry,

or mirrorlike replication of parts

around a visual axis.

Symmetry is viable if the problem calls for it.

Symmetry: *Balanced propor-*

tions; correspondence in size,

shape, and relative position of

parts on opposite sides of a

dividing line or median plane

or about a center or axis.

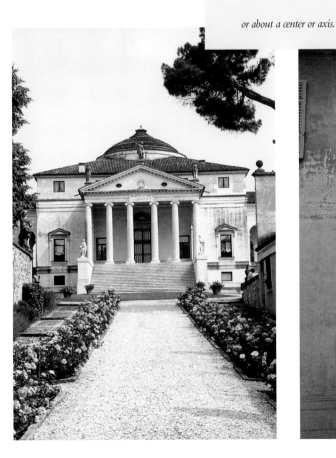

A more challenging problem for the
designer is to achieve

asymmetrical balance.

These solutions are often more visually
interesting, and are also more common…

first, because most
problems do not suggest
a symmetrical solution...

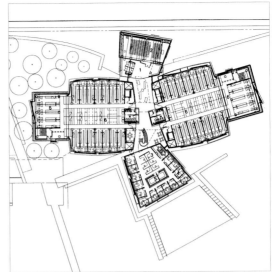

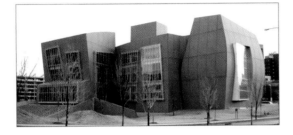

and, second, because symmetry exists only
when an object is viewed in isolation from its
surroundings. Our visual world, in total, is never
symmetrical (see *Context & Scale*, p.92–101).

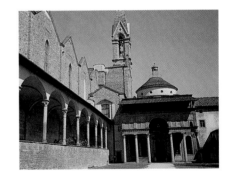

It's also interesting to note that objects in the natural
environment so often cited as displaying symmetrical
balance are, in many cases, not perfectly symmetrical
and are really examples of asymmetrical balance.

*Even the human face can
display asymmetry, as
shown by these photoma-
nipulations.*

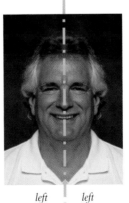

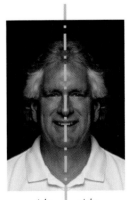

left left right right

Asymmetrical balance is created in a variety of ways. A smaller shape can balance a larger shape through the manipulation of…

placement…

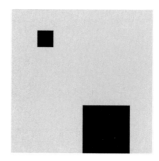

Placement higher in the visual field imparts a greater energy to the smaller square.

orientation…

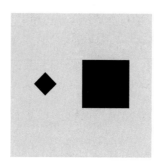

A similar energy is achieved by rotating the smaller square off-axis.

value…

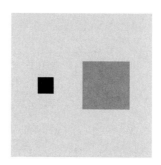

A darker value (more contrast with the background) gives the smaller square greater visual weight.

or color.

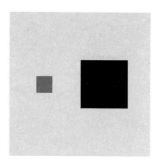

Likewise, the smaller square is energized through the use of color.

When designing to achieve symmetrical balance, avoid near-miss symmetry. Minor deviations can appear as mistakes.

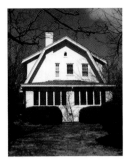

In each of these house elevations, it is clear the designer intends to achieve symmetrical balance. Yet the symmetry and the balance are not quite resolved and the effect is unsettling.

Look to the problem for the appropriateness of a symmetrical or asymmetrical solution.

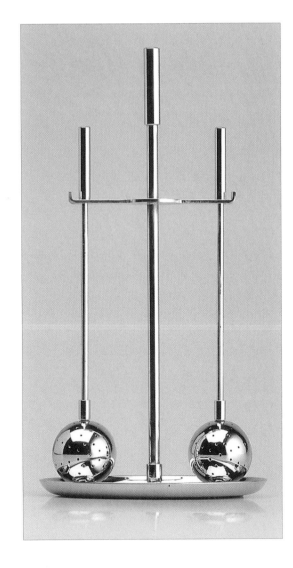

b a l a n c e

DESIGN
S H O P

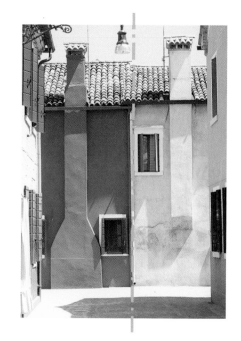

You will notice that we discuss balance about

a vertical axis.

Our eyes demand equal visual weight to the left
and right of a vertical axis quite simply because of
how they are located within the face and on the
human figure.

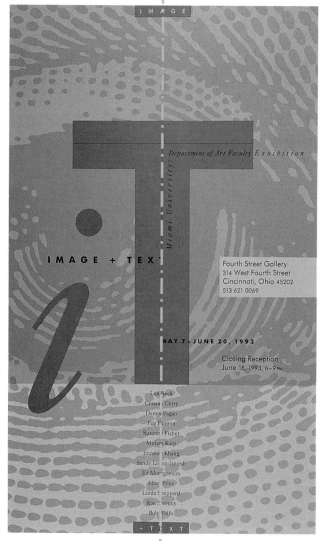

The same is not quite true with

a horizontal axis.

Greater visual weight below the axis is needed to counteract lesser visual weight above the axis, due to our perception of gravity.

To prove that this is true, look at the design of the number 8 and the letter S to the right. More visual weight is given to the bottom of the letterform to make it appear balanced. When the form is turned upside down it looks top heavy.

 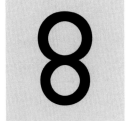

In a similar way, we refer to the "visual center" when mounting or framing a picture. In order to create balance about the horizontal axis, we leave more space at the bottom of the mat, so that the picture will look visually centered in the frame.

One of the greatest challenges to the designer is to create visual balance in a three-dimensional environment. Three-dimensional design is perceived, essentially, as an infinite series of two-dimensional images. Each of these images can be evaluated in terms of its visual balance.

 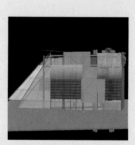 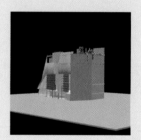

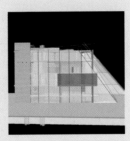
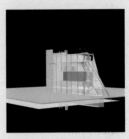

Another way to look at balance in a composition is to compare positive and negative space. In two-dimensional design we talk about

figure-ground balance

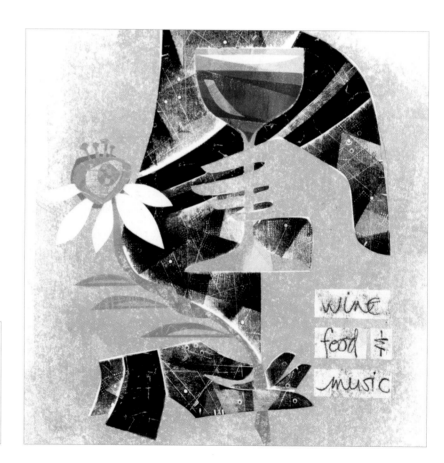

...and in three-dimensional design

mass-void balance.

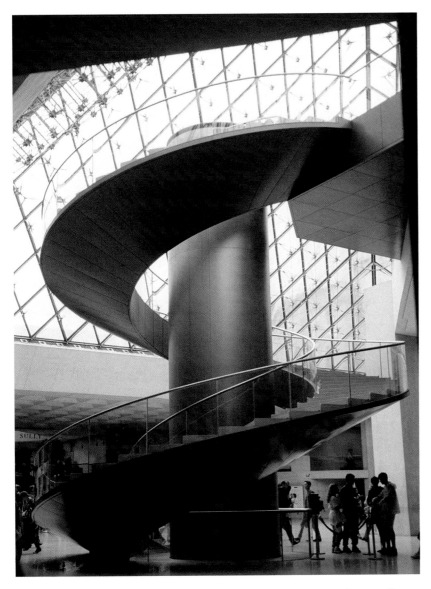

Mass and void are, of course, three-dimensional qualities. They are abstracted two-dimensionally, right, to conform to book format.

Once again, the eye will seek some kind of balance between figure and ground, and between mass and void.

The designer also must be conscious of the need for white space.

White space allows the eye to rest.

As a general rule, avoid the ambiguity created by equal figure–ground balance. If not intentional, this will be disconcerting, and possibly confusing, to the viewer.

If intentional and related to the problem, as with these examples, this technique can be very effective.

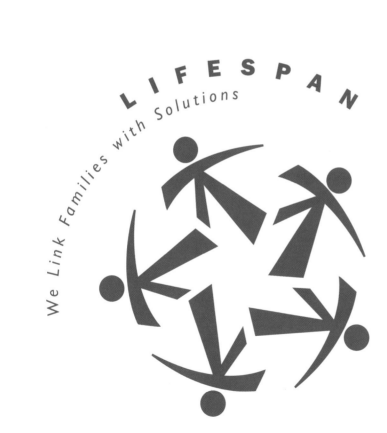

LIFESPAN

We Link Families with Solutions

These two logos demonstrate effective figure-ground ambiguity. The designer intends the viewer's attention be drawn equally to figure and ground. In the logo above, the cross and the door, symbolizing Catholic Social Services, are given equal importance. To the left, the human figures form a central star. The fact that the eye bounces back and forth between the two elements gives the logo a playful attitude.

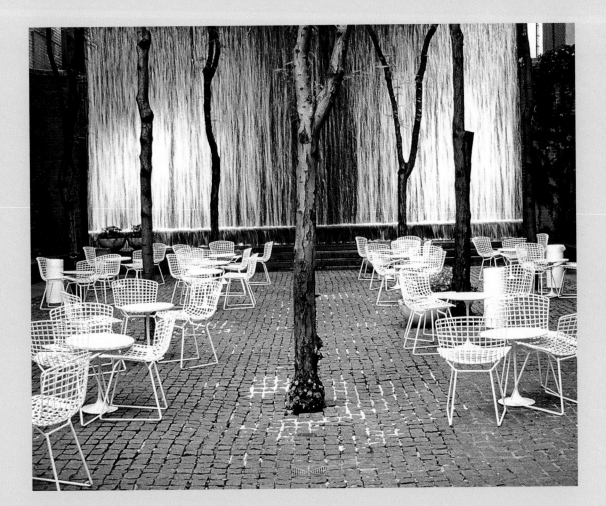

Visual balance in a composition is affected by
the specific placement of its parts. Let's look at
how decisions about placement impact design....

Placement: *An act or*

instance of location.

3.8

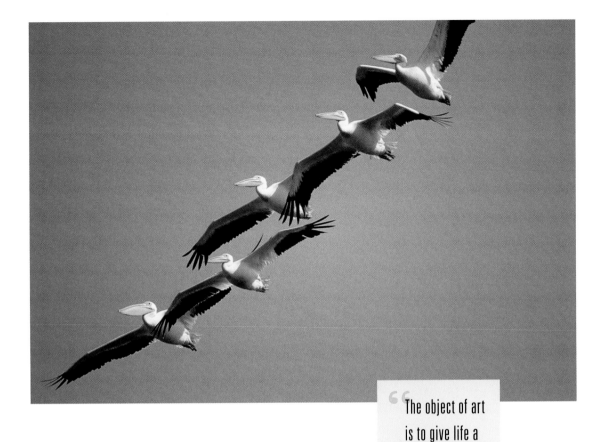

> " The object of art
> is to give life a
> **shape.** "
>
> —Jean Anouilh

Any design problem requires that the designer carefully evaluate the specific *placement* of parts. We look first at how a part—or element—is oriented. The orientation of a part will affect how it is perceived.

Horizontal lines, planes and volumes create a sense of groundedness or resolution, due to our understanding of gravity.

Vertical lines, planes and volumes defy gravity, on the other hand, creating a sense of energy or excitement.

 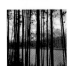

Diagonal orientation implies kinetic energy and increases the level of excitement even further.

Parallel orientation creates unity in a design...

but avoid the line that just misses being parallel, as in the manipulation to the far right. Like other "near-misses," it will look like a mistake.

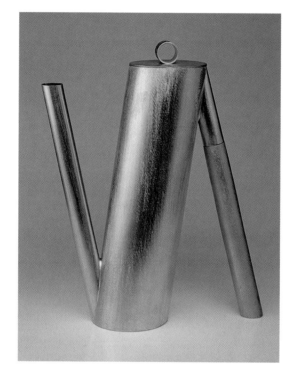

An object placed in the top of a field has a greater visual energy than the same object placed lower in the field because it appears to be defying gravity (see p.108).

When moved to the bottom of the field, the same object appears more stable.

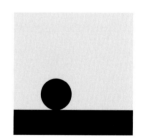

Respect the center: it has a greater impor-
tance because of where it is. If placement
occurs away from the center, it can
appear neglected (like a hole).

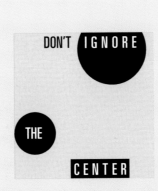

Also avoid placing objects just off the center.
Again, this will appear to be a mistake or
near-miss.

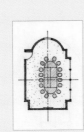

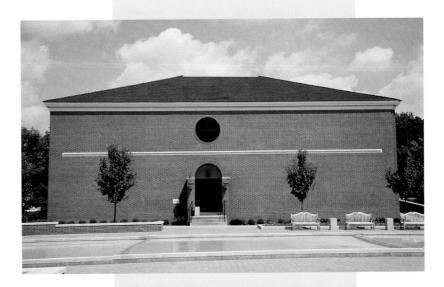

Don't crowd the edge.

Without enough space at the margin, tension will be created.

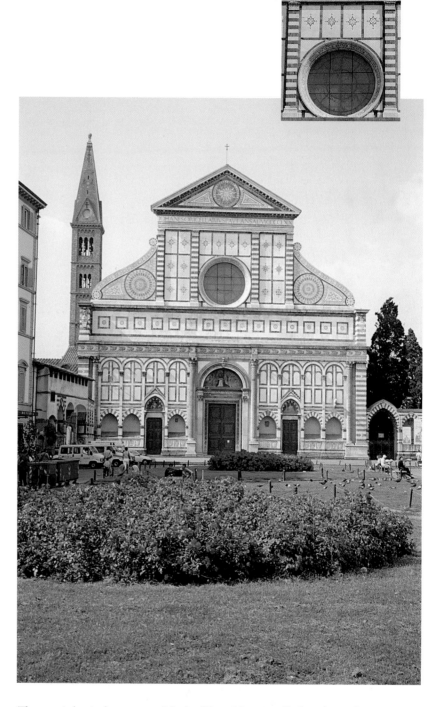

The rose window in the reconstructed façade of Santa Maria Novella (by architect Alberti, in Florence, Italy) crowds the horizontal band at its lower edge. (The relationship of these elements is better understood when we learn that Alberti's design respected both the existing window location and a strict proportional system. See Proportion, p.130.)

Allowing an object to move past the edge,
however, can add to the dynamic quality of
the design by increasing the perceived field
of view. Graphic designers call this a

bleed.

As the object begins to bleed off the edge,
what is figure and what is ground becomes
less clear and an interesting visual play results.

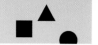

Alignments

create visual relationships between elements in space and help to unify a design. When in doubt, align related or adjacent elements, using…

edge alignment…

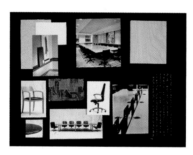 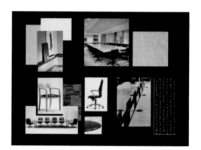

In this presentation board, the improvement in the second image, achieved by strengthening edge alignments, is subtle but real. Although these images are used to illustrate the principle of alignment, the careful examination of several other design issues—including grouping, unity-variety and craft—will create further improvement.

or center alignment.

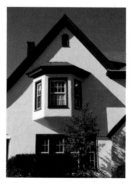

Failure to do so will give the impression of unintentional randomness.

Modular or grid relationships

inherently provide alignment and bring order to the design.

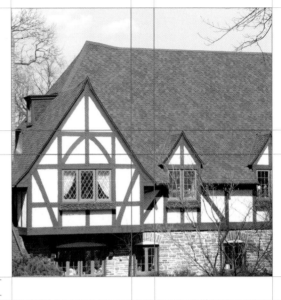

The three images on this page represent different ways of using a grid to organize space and information. The lines covering the page illustrate the grid used to lay out this book. These modular systems bring order and clarity to the information.

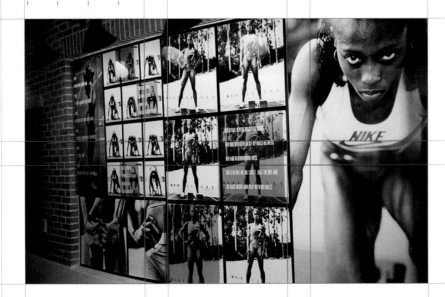

Finally,

the illusion of depth

can be an effective design strategy and can be
created in several ways, including…

perspective…

overlapping elements…

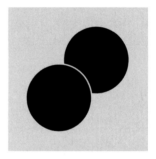

*contrasting tonal
qualities…*

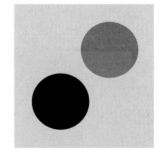

or contrasting color.

*Juxtaposing warm colors, such as red and yellow, which
advance, with cool colors, such as blue and purple, which
recede, will create the illusion of depth.*

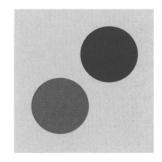

Basler Freilichtspiele
beim Letziturm im St. Albantal
15.-31. VIII 1963

Wilhelm Tell

This poster masterfully uses perspective, overlapping elements, and contrasting tonal qualities to convey the strong illusion of depth.

Next, let's look at the principle of proportion…

3.9

proportion

Proportion: *The relation of*

one part to another or to the

whole with respect to magni-

tude, quantity or degree.

> "Beauty—the
> adjustment of all parts
> proportionately so
> that one cannot add
> or subtract or change
> without impairing
> the harmony of
> **the whole.**"
>
> —Leon Battista Alberti

We often speak of the need for good design to be "in proportion." What does this mean? Proportion is the relationship of one part to another, and can apply to many types of relationships: length to length, size to size, length to width, placement, value or color—pretty much anything that can be quantified. Unfortunately, we use the terms "in proportion" or "out of proportion" to mean different things.

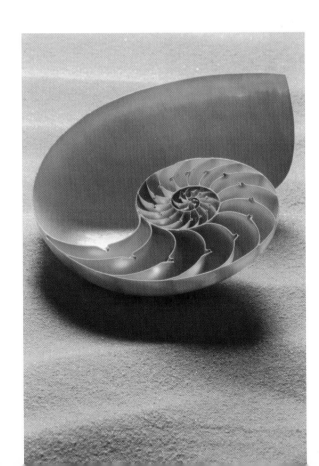

p r o p o r t i o n

Proportion can refer to a scalar relationship as

defined by the problem.

We would characterize each of these examples as displaying poor proportion. The garage, the telephone number on the business card, and the architectural column all seem to be "out of proportion."

Joseph Smith Associates

231 Round Street
New York, NY 10013

Joseph Smith, Owner & Architect

1-800-555-4286

Architecture, Interior Design, Graphic Design
We do it All!

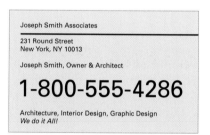

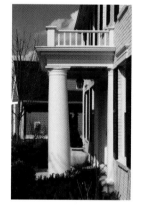

Sometimes, however, our criticism is based on a conception of what *we* see as the problem, rather than on the problem as it really exists. For example, the garage is not out of proportion compared to the house if, in fact, the problem calls for a larger garage. In the photograph of the column, perceived misproportion is dependent on our understanding of material and structure.

When we view the above images as figure–ground abstractions, proportional relationships are not so objectionable.

The image at the right speaks to this point. At first glance, the proportion of the windows to the building may seem too small. But once we learn that this is a farm building in rural Switzerland built with post and beam construction, and that these side rooms in which the windows are located were seldom used, the size of the windows makes more sense.

Likewise, the chimney in the Williamsburg, Virginia, house below appears too large; yet the proportion seems more correct when we understand this feature as the sole heat source for the house.

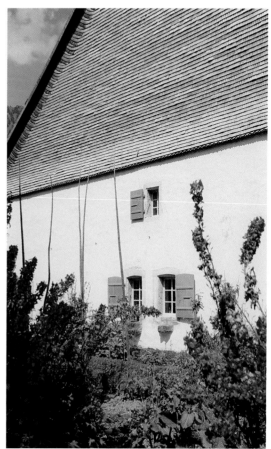

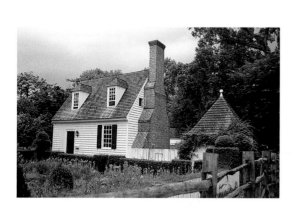

2

Proportion can also refer to the

human scale.

Design is in or out of proportion as defined by human use. (*See Context & Scale*, pp.92–101)

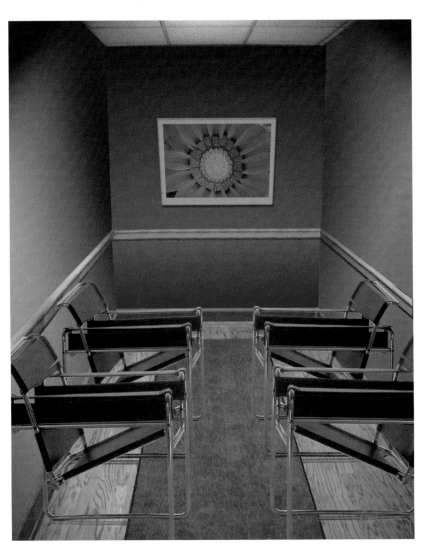

The dimensions of this waiting area do not allow for a comfortable conversational grouping. What defines our understanding of a hallway *versus a* room?

1:2

2:3

3

Proportion also can be evaluated in the abstract:
Are there "correct" proportional relationships?
Here it gets tricky.

We observe the frequent recurrence of the

golden section

relationship in nature and in mathematics.

3:5

5:8

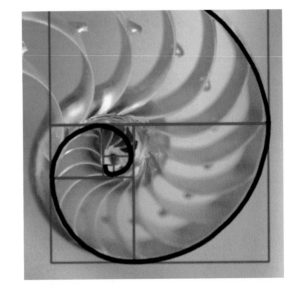

8:13

Golden Section: *A proportion (e.g. the length*

and width of a rectangle and their sum) in

which the ratio of the whole to the larger

part is the same as the ratio of the larger part

to the smaller.

Fibonacci Series: *An infinite sequence of inte-*

13:21

gers in which each succeeding term is the

sum of the two immediately preceding.

21:34

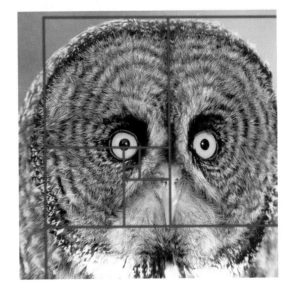

placement

The frequent recurrence of the

golden section

relationship in nature suggests the merit of using

these proportions in the designed environment.

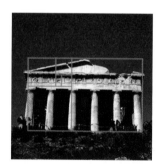

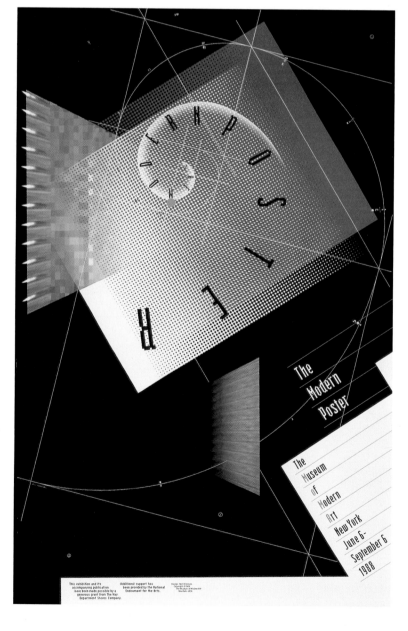

a 1:1 relationship

is also quite common and implies a sense of stability.

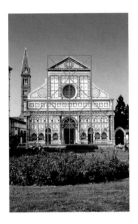

The 2:1 relationship, or double square, is a variation on the 1:1.

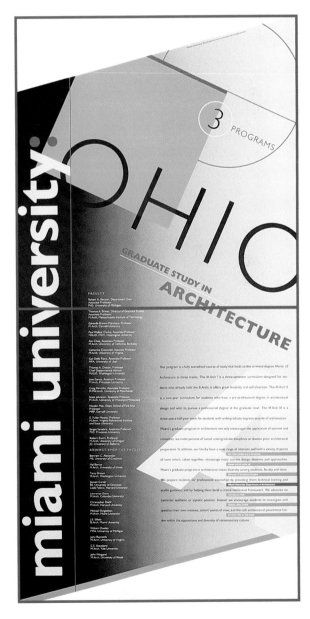

proportion

Many other proportional relationships are evident in natural and designed environments and can be used to good effect. However…

the designer may wish to avoid the ambiguity created by a near-miss relationship…

and may decide to articulate or visually divide particularly high proportional ratios.

What we would characterize as perhaps most important to the designer's understanding of proportion is the need to treat proportional relationships consistently.

Once a proportional relationship has been established, it will likely recur across the design at many scales.

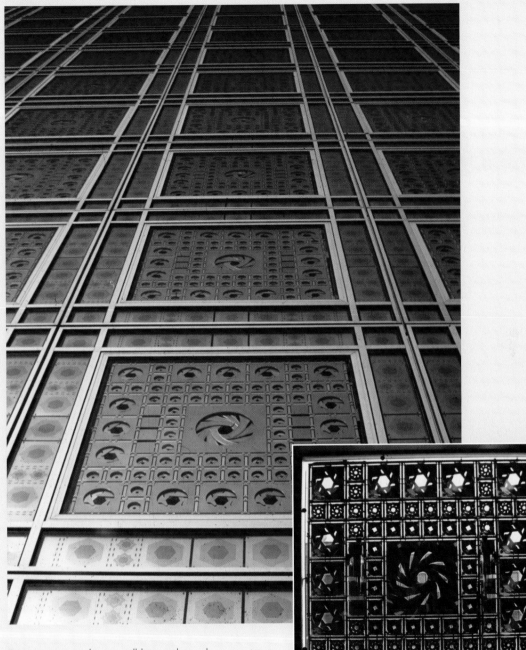

Proportion in a design will be evident when consistent.

However, remember the need for unity and variety.
Not everything needs to have an identical proportional
relationship.

proportion

Designers make use of

modular or grid systems

as a way of respecting proportional relationships

(see modular or grid relationships, p.127).

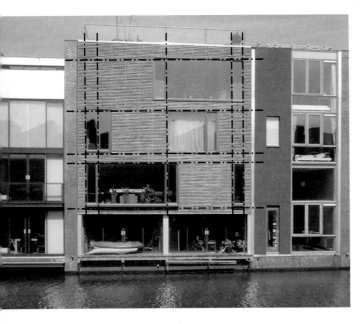

ANIMAL KINGDOM

Parts in a design are often enlarged or reduced. Be careful to

maintain proportional relationships.

For example, the same pen cannot be used to enlarge this letterform without affecting the stroke width to letterform height ratio.

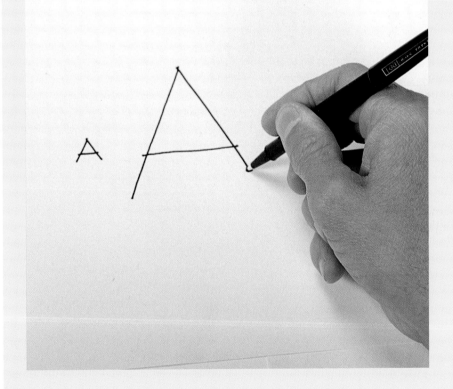

So is design only to be understood at the level of the visual?

3.10

3

meaning

Meaning: *Implication of a specific significance or intention.*

> " It's not rocket science. It's social science—
> the science of understanding people's needs
> and their unique relationship with art, litera-
> ture, history, music, work, philosophy, com-
> munity, technology and psychology.
>
> # The act of design is structuring and creating that balance. "
>
> —Clement Mok

Design can be understood and appreciated at many levels beyond the purely visual. Design has meaning. Return for a moment to our definition of design:

to conceive and plan out in the mind; to have as a purpose; to devise for a specific function or problem; an underlying scheme that governs functioning, developing, or unfolding.

First and foremost, design is about solving a problem.

If it fails to solve the problem, it fails as design—no matter how visually interesting or innovative. The need to solve a given problem is what separates design from painting or sculpture.

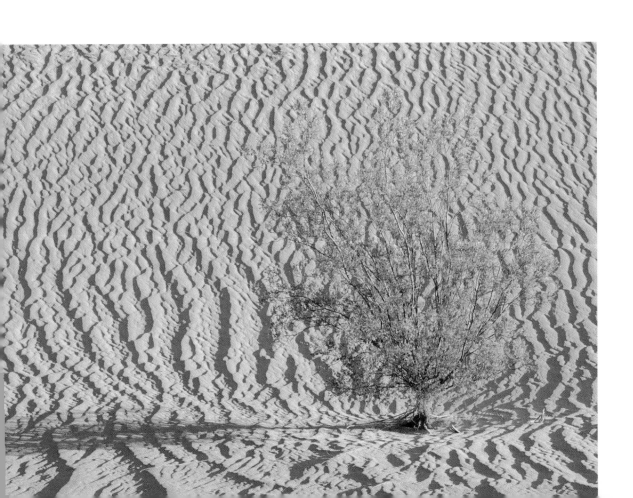

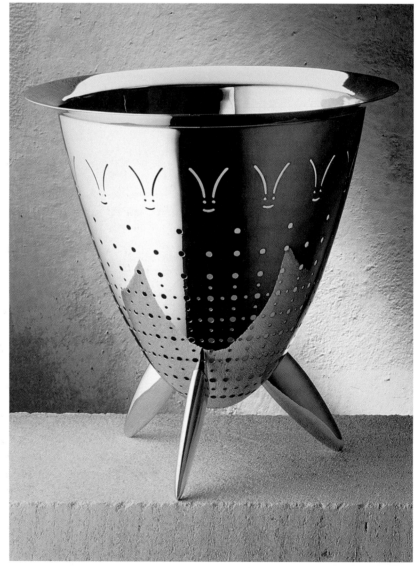

In fact, many of the best design solutions are derived from a careful scrutiny of the

problem.

Be willing to reinterpret the problem as given; a good designer not only challenges the solution but challenges the problem.

But doesn't a design need to do more than
solve a problem?

What about
creativity?

Design is about a fresh look, a new spin, a
creative interpretation. It should reflect the
problem, but also the designer.

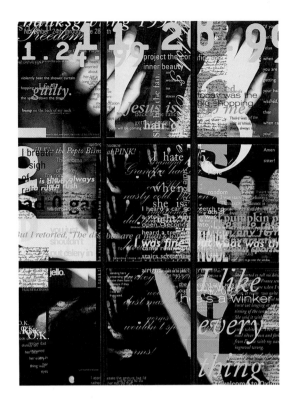

"You should never lose sight of the fact
that you are solving somebody's prob-
lems. At the same time, you should solve

your own as well."

—Lucille Tenazas

Be careful here!

Creativity matters, but not at the expense of good design.

Creative does not mean bold, or different, or "in your face." It is not about ego. Recognize the problem that calls for a more subtle (and often more interesting) kind of creativity.

"In our time there are many artists who go for novelty, and see their value and justification in novelty; but they are wrong—novelty is hardly ever important. What matters is always just the one thing: to penetrate to the very heart of a thing, and **create it better.**"

—Henri-Marie-Raymond de Toulouse-Lautrec

When we criticize a design as being "uncreative," more likely it suffers for lack of good design. Rethink these images below in terms of unity, variety, focus, contrast and other visual principles, and they are quickly improved.

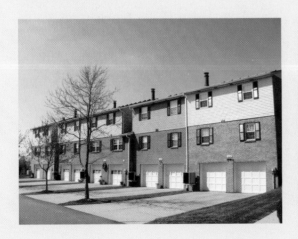

Good design is good once, not twice

...it is specific to its time, its place and its users.

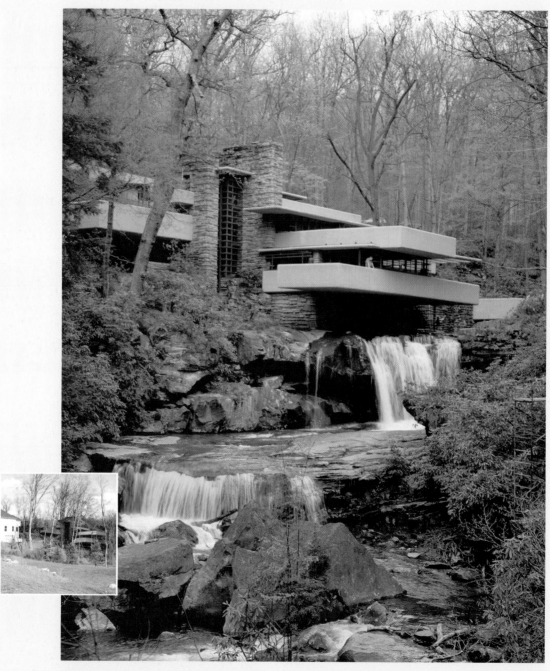

A reproduction of Frank Lloyd Wright's classic home "Falling Water," for these reasons, is no longer good design. Instead, it plagiarizes the original.

Don't confuse plagiarism and

mass production,

however; a mass-produced piece can still
be a good design.

Mass production is inherent in the problem
for the graphic and product designer.

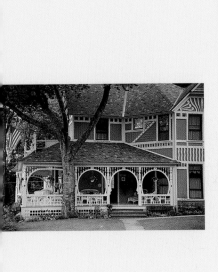

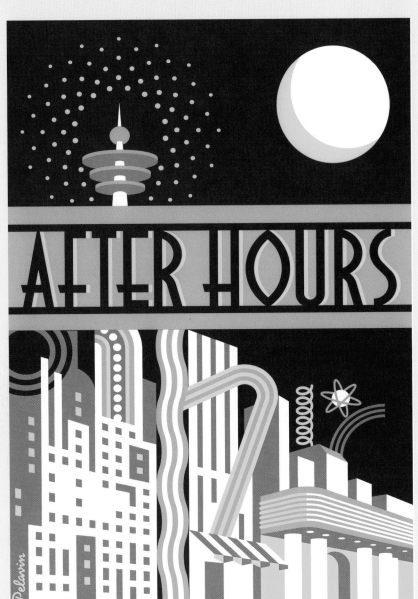

Also use a *stylized solution*
(e.g. Art Deco, Victorian, Classical) only when the
problem or context calls for it. This decision does not
negate the need to be innovative.

Study a style carefully. A good stylized design is diffi-
cult and requires a thorough understanding of the
style's characteristics. It is also important to under-
stand the historical and cultural context of a style.

Avoid using stylized solutions arbitrarily. This only serves to keep people in a comfort zone, surrounded by the familiar. Good design respects our need for the familiar while still understanding the problem as unique to the user and the designer.

Avoid following trends just because "everyone else is doing it." Look to the problem for the solution.

Try to avoid the literal, clichéd, or easy solution to a problem. Such solutions may be fun, but their impact quickly fades. They are "one-liners."

BIG IDEA ASSOCIATES

"Good design, at least part of the time, includes the criteria of being direct in relation to the problem at hand —not obscure, trendy, or stylish. A new language, visual or verbal, must be couched in a language that is **already understood.**"

—Ivan Chermayeff

When meaning is conveyed more abstractly, when it is revealed gradually, a design solution becomes more interesting and complex.

Design is about ideas…

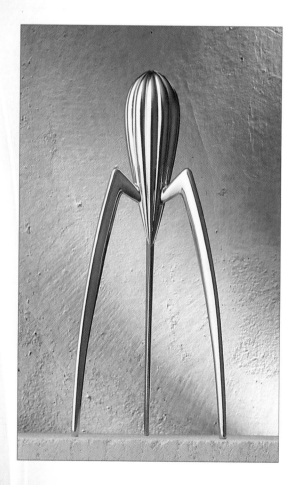

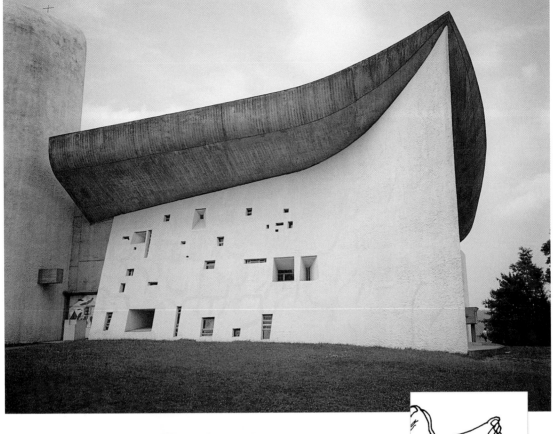

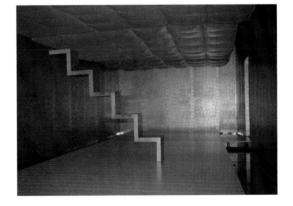

"Content comes first...yet excellent design can catch people's eyes and impress the contents **on their memory.**"

—Hideki Nakajima

*...ideas that guide design
decisions at all scales.*

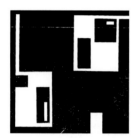

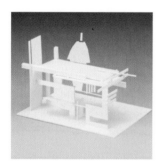

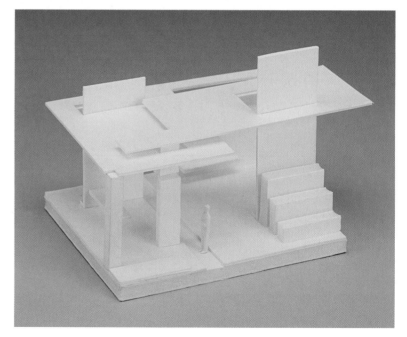

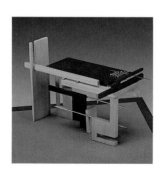

*In this student project, the design of a two-dimensional graphic, a bracelet, a reception desk and
a small chapel are all guided by the same ideas. These ideas are revealed gradually to the viewer
as they interact with—and begin to understand—each design solution.*

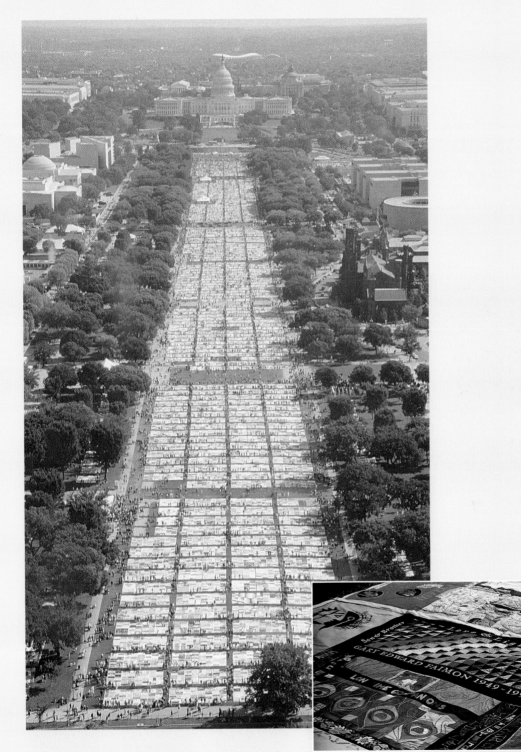

Looking down from the Washington Monument onto the Mall,
the viewer experiences the final showing of the entire AIDS
Memorial Quilt, made up of individually-created quilts laid side
by side. (It has since grown too large to be shown at one loca-
tion.) Each quilt is part of a larger section, which, in turn, is part
of the whole: a wonderful design—and experience—at all scales.

Design can evoke an emotional response.
It is about communication on many levels.

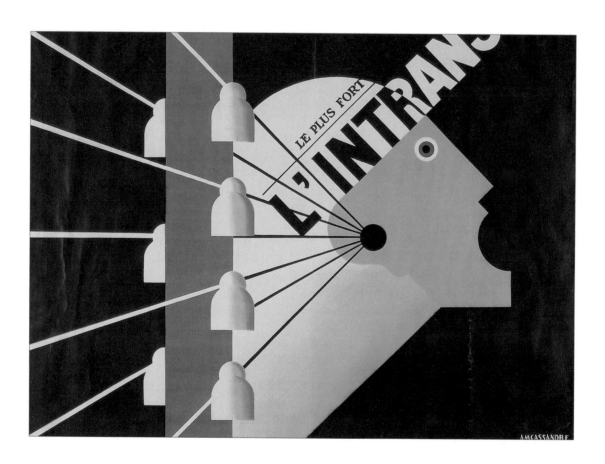

FRIENDS
of fine arts

Začarovaný kruh
drogové závislosti
Polský film
Režie:
Andrzej Trzos-
Rastawiecki

J SEM
PROTI

Good design does not "assemble" or "decorate" arbitrarily or in a way that overloads the viewer with visual information.

A design solution does not need to be "layered with meaning" to be good, as long as it *carefully considers visual principles.*

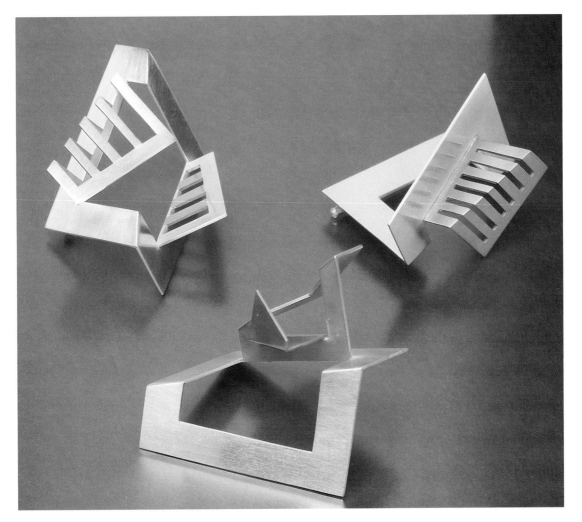

The designer's primary concern in the creation of these pins was the exploration of form. Any specific meaning derived by the viewer is more interpretive.

Carefully consider *cultural readings* of design. Design has a communicative power which can exist only in a cultural context, because signals and signs transmit information in a predetermined and learned code.

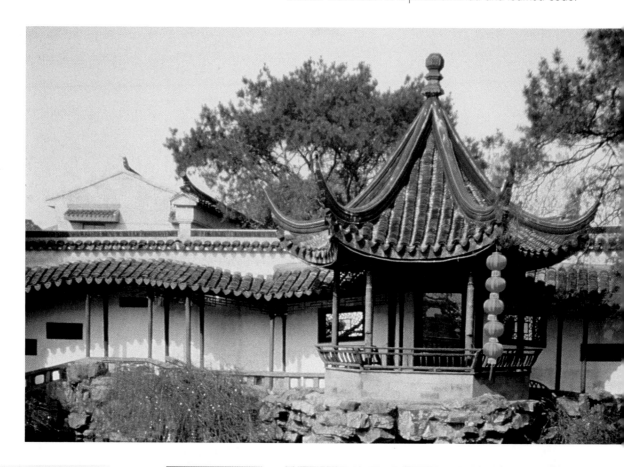

"You have to be interested in culture to **design for it.**"

—Lorraine Wild

Be aware of associations. If unintended or confus-
ing, the meaning can be misunderstood. In this logo,
the cruciform shape strongly relates to the café
name, but it also has other connotations: Christianity,
Switzerland, and medical assistance, to name a few.

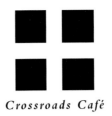

Crossroads Café

If intentional, *associations*

can be quite powerful in conveying meaning.

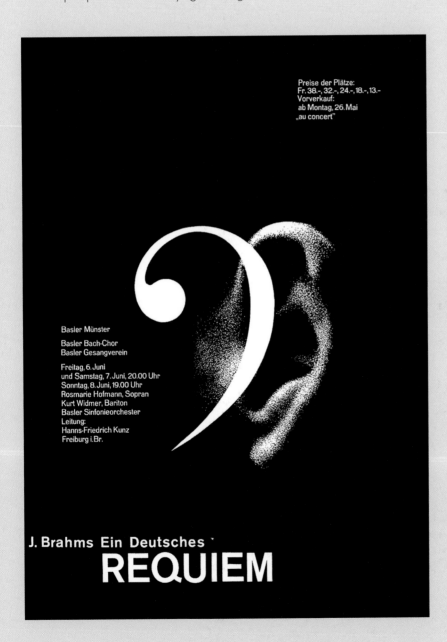

Preise der Plätze:
Fr. 38.-, 32.-, 24.-, 18.-, 13.-
Vorverkauf:
ab Montag, 26. Mai
„au concert"

Basler Münster

Basler Bach-Chor
Basler Gesangverein

Freitag, 6. Juni
und Samstag, 7. Juni, 20.00 Uhr
Sonntag, 8. Juni, 19.00 Uhr
Rosmarie Hofmann, Sopran
Kurt Widmer, Bariton
Basler Sinfonieorchester
Leitung:
Hanns-Friedrich Kunz
Freiburg i. Br.

J. Brahms Ein Deutsches
REQUIEM

OXFORD
CLINIC

Good design evolves through an iterative *process* in which solutions are tested against the problem requirements, then refined and retested, eventually resulting in a final product.

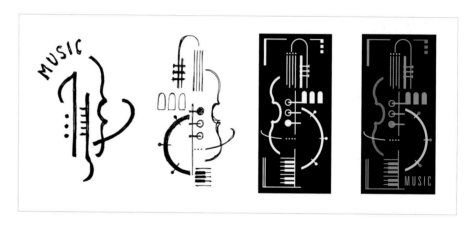

Sometimes process is reflected in the product. The archaeology of a city reveals design process; its architecture reflects time and conveys meaning. Even though the image on the right may ignore principles discussed earlier, the authors appreciate its complexity and inherent meaning.

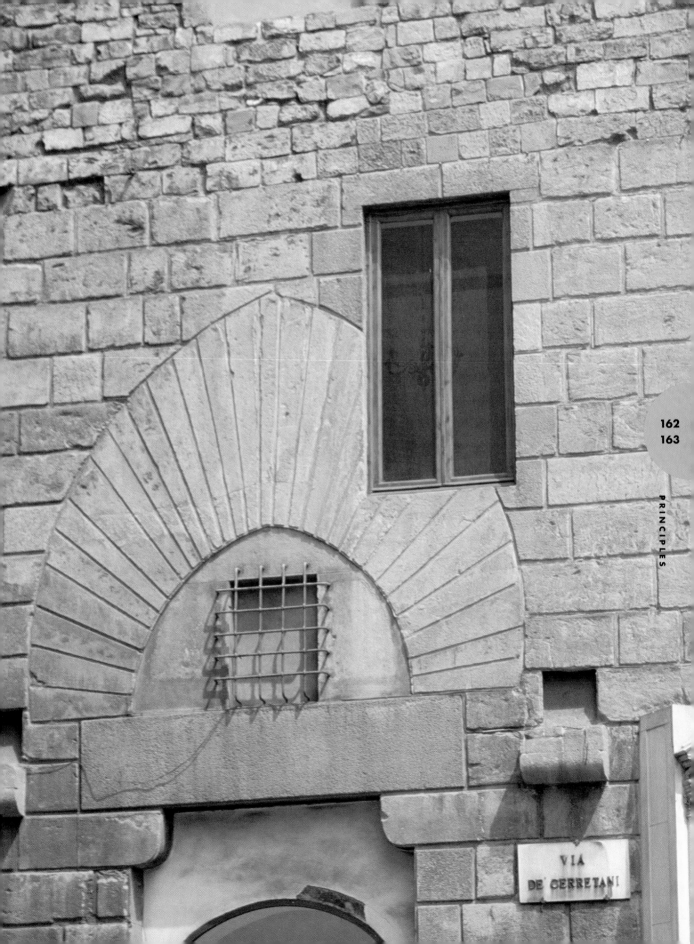

VIA
DE' CERRETANI

Express functions,
materials and
structure with

honesty.

Break this rule rarely
and with intent.

When the parts relate
poorly to their function,
the message is one of a
designer who does not
understand the problem.

*Cut-off columns, a decorative
mansard roof, window shutters
that disregard their historical
purpose, and dishonest (fake)
building materials are all poor
design choices.*

*We note that if a design solution
is temporary or greatly limited
by cost (exhibit design or store
display, for example), the deci-
sion to use imitative materials
may be more appropriate.*

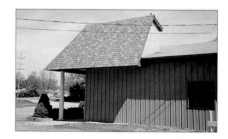

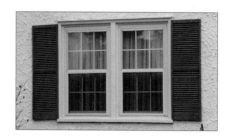

Always remember the need for good

craft and execution.

These are essential to good design. But
the reverse is not true: good craft does not
necessarily guarantee good design.

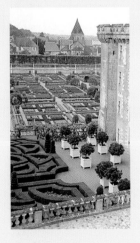

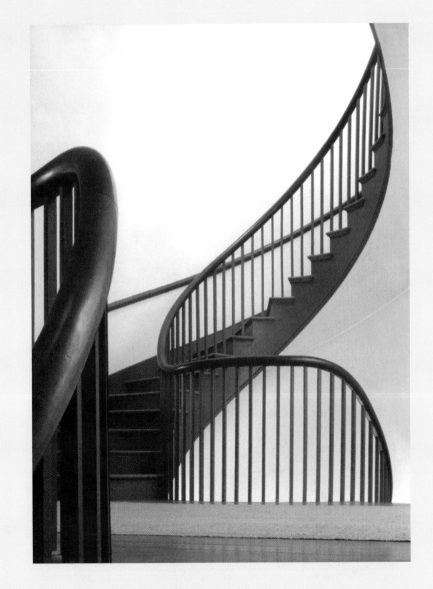

For the authors, the images on this page convey both design interest and design resolution, even though they may violate principles presented earlier. Again, in the hands of the skilled designer…

principles can and should be challenged and reinterpreted.

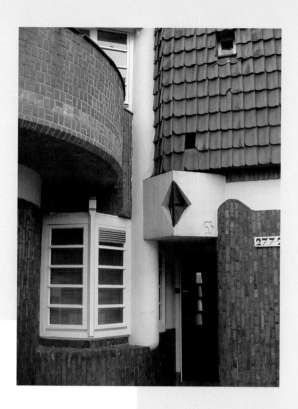

As we select images for this book, we notice how frequently we return to the natural environment for "good" examples, and how frequently we look to the natural environment for inspiration. Somehow, these images seem to get it right, again suggesting that

the study of design is truly multidisciplinary.

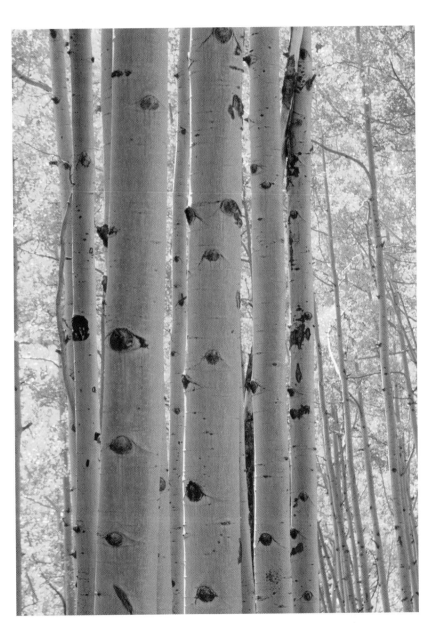

Let's tackle some case studies to see how the principles discussed in the preceding chapters apply to the design process.

4

process

Process: *a series of actions,*

operations or decisions

leading to a solution, end,

or final product.

case studies:

① ② ③ ④

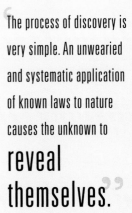

"The process of discovery is very simple. An unwearied and systematic application of known laws to nature causes the unknown to **reveal themselves**."

—Henry David Thoreau

The preceding principles may all make sense in the abstract, and yet may be difficult to apply to a more complex and multifaceted design problem. In this chapter, we attempt to "make real" these principles by illustrating how they come into play in case-study problems. Again, there is no single correct process any more than there is a single correct solution. A design evolves in any number of ways. Ideas are tested against the requirements of the problem, revised, and retested. Just as important, if a solution is to qualify as "design," these ideas are also tested against *design principles*. Our list of examples is necessarily incomplete, but includes representatives from graphic design, interior design, product design and architecture.

case study 1

Problem: Create a logo for a new multidisciplinary organization named "Arts." Represent the following: integration, collaboration, creativity, and process.

Research: All design problems begin with some degree of research. Designers must familiarize themselves with the content of the problem and with possible functional limitations. With this particular problem, the designer studied the various design disciplines represented by this new organization, including a review of images related to each discipline: architecture, dance, design, music, studio arts and theatre.

Design Exploration: The second phase of design process is generally design exploration. This includes intensive ideation—an exploration of a wide variety of possible design directions. The wider the range of initial ideas, generally the more successful the final solution. Due to limited space, we will focus solely on one idea track, its design refinement, and the final solution.

Main Idea Track: During the course of the design exploration it became obvious that the use of an illustrative image or symbol would focus too much attention on one particular type of "art." To keep the logo more abstract and inclusive of all the art disciplines, the designer decided to pursue a typographic track using the letterforms in the word *arts*.

The designer explored different typefaces for inspiration. A sampling is shown below:

ARTS

ARTS

ARTS

ARTS

ARTS

ARTS

Due to the contemporary nature of the organization, the designer decided to pursue a sans-serif typeface. Gill Sans, shown below, gives a modern feel, but also has a softer, humanistic approach due to the irregular geometry of some of the letterforms. The designer next explored various weights. The light version felt too airy; it's important for a logo to have a certain amount of weight due to the variety of applications and uses. The bold version seemed too heavy and lost a sense of elegance.

ARTS

ARTS

ARTS

The medium version seemed to have the right degree of weight. Having explored solely all caps up to this point, the designer chose to investigate lowercase and a combination of upper- and lowercase in the medium weight of Gill Sans.

- Using solely lowercase can give a sense of informality, which seemed inappropriate for this organization.
- The upper- and lowercase version's shape seemed awkward and not as compact as the all caps. (When designing a logo it's very important to consider the outer shape it creates. See below.)

arts

ARTS

In order to give the logo a more unique quality that would communicate the characteristics identified in the problem statement, the designer began to experiment with the type, first with the kerning (space between the letters) and next with the vertical and horizontal type scaling.

ARTS

Normal kerning

ARTS

Too tight: ambiguous touching of letterforms

ARTS

Too loose: again, too airy, lacks grouping

ARTS

Better, but needs more interest, more creativity

ARTS

Horizontal scaling distorts the type and makes the horizontal strokes too thick: poor letterform proportion. ★

ARTS

Vertical scaling also distorts the type and makes the vertical strokes too thick. The type looks like it's been sat upon. ★

★*Please note that typefaces are created specifically as extended (wide), condensed (narrow), or regular. The proportions of the letterforms are carefully studied by the type designer. Although computer technology allows for easy manipulation of letterform scaling, it is not sensitive to maintaining proportional relationships.*

Design Refinement: Following the explorations within the main design concept, some important decisions were made to narrow the direction. Previous studies confirmed the appropriateness of the approach, but there was a need to add a more unique quality to the logo, something which communicated *process* and *creativity*. One way to express these ideas was to show only a portion of the letterforms, as if they were appearing and in the process of being created.

A first thought was to simply delete half the letterforms. The readability of the second try was better than the first, but there were still aesthetic problems. The weight distribution throughout the logo needed consistency; specifically, the vertical stroke of the T was too thin. There was also a problem with overall weight. Further, the letterforms weren't well grouped; they lacked clear visual connection with one another.

A second thought was to delete a horizontal section of letters. This was also problematic. The triangle of the A became a Greek delta—an unwanted association. Another problematic association was the fact that the letters looked liked they were sinking—not exactly positive. Readability was again an issue. Was the second letter an R or a B?

So what else could be tried? The deletion of portions of the letterforms to represent process and creativity still seemed like a good idea, but the designer realized that large portions of the letterforms could not be deleted without affecting readability and connection. The next tactic was to delete strategic smaller parts, while still maintaining the most essential and unique portions of the letterforms.

At this point the designer felt that the letterforms were well resolved, and the logo seemed to communicate a more unique, creative approach. Yet, the ideas of inclusion, collaboration and integration seemed lacking. The designer was also concerned about the overall weight of the logo. In small applications, like a business card, would the logo above still be too airy and lack visual impact? The study below explores the integration of a shape, or ground, to provide more overall mass and impact.

The designer also wanted to investigate color. Bright, vibrant colors were explored to communicate a modern and energetic attitude. An initial study highlighted the S with color to communicate the plural nature of the arts organization. This worked on one level but, depending on the interpretation, could communicate divergence, or a lack of integration—the opposite concept from that which was intended. The S also becomes an unintended focus. For these reasons, the designer chose to go with equally vivid, but differing colors for each letterform, to express variety within a unified design.

Final Refinement: The integration of a shape was the last step in the refinement stage. The rectangular shape seemed too rigid and confining. A fluid curved shape more effectively communicated inclusion, collaboration and continuity.

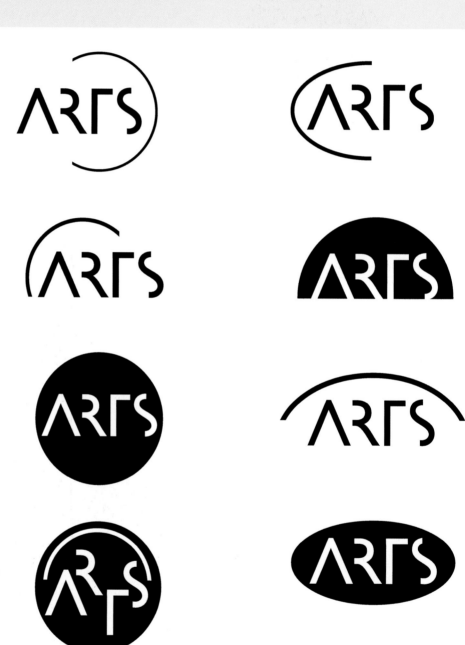

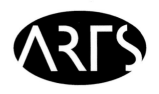

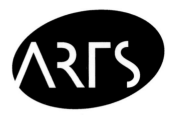

The investigation of shapes to the left yielded some interesting results, but most were problematic. Again, unwanted associations arose; in several cases the shape implied an eye or a rainbow. The purely circular shapes looked too much like buttons. The two studies on the bottom were interesting, but the one on the left was chaotic and lacked readability. The oval on the bottom right worked well with the overall letterform shape, but the flat horizontal orientation lacked interest and energy.

In order to add a more interesting play of figure and ground, the letterforms were allowed to bleed off the edges of the oval, above. To add energy to the composition the oval was tilted, which also implied a spotlight or artist's palette—perfect, though not too literal, associations for an arts organization.

Final Solution: The final solution is shown at right in both black-and-white and color versions. Subtle modifications included:

- extension of the oval to avoid association with an egg
- proportionally greater space at the bottom of the oval
- bleed of letterforms on both sides of the oval

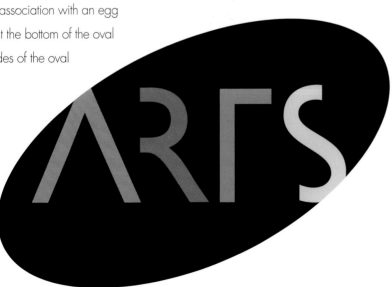

case study 2

Problem: In this student project, the assignment was to create a space plan for a small (6000 sq. ft. [557m²]) office tenant relocating to a partial floor of a high-rise office tower. Space needs and adjacency requirements, as well as a floor plan of the raw space, are shown below.

By definition, the space plan is a diagrammatic floor plan that fits functions to available space and determines total space needs, but that also begins to define a two-dimensional structure for what will eventually become three-dimensional interior architecture. The designer should always be thinking three-dimensionally and conceptually while developing the two-dimensional space plan. Understanding this, we focus here specifically on the development of the space plan.

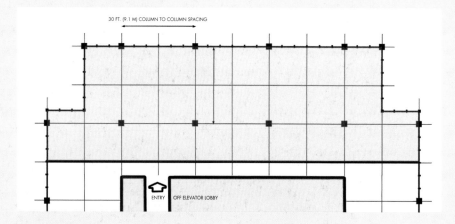

30 FT. (9.1 M) COLUMN TO COLUMN SPACING

ENTRY OFF ELEVATOR LOBBY

Space Needs
(4) A Offices @ 14 × 6 ft. (4.2m × 4.8m)★
(8) B Offices @ 12 ft. × 12 ft. (3.6m × 3.6m)★
(8) Secretarial Workstations @ 6 ft. × 10 ft. (1.8m × 3m)★
(6) Staff Workstations @ 6 ft. × 10 ft. (1.8m × 3m) (2 can be smaller)
(1) Large Conference Room @ 20 ft. × 20 ft. (6m × 6m)
(2) Small Conference Rooms @ 10 ft. × 15 ft. (3m × 4.5m)
(1) Workroom @ +/- 400 sq.ft. (37m²) (centrally located)
(1) Kitchen @ 100 sq.ft. (9m²) (adjacent to Reception and Large Conference Room)
(1) Reception, with desk and seating (locate adjacent to elevator lobby)
 ★(A and B Offices and Secretarial Workstations to be grouped together)

Much like completing a jigsaw puzzle, the space plan requires that many different parts be fit together while preserving sometimes complex functional adjacencies. This can be a difficult process! Driven by this challenge of successfully fitting functions to the plan, the beginning designer often "drafts" these functions into place, moving from left to right across the plan, committing lines to paper too quickly. The sketch below is such an example. Although it may "function," it fails at the compositional level. It is not yet designed. When translated (often "extruded") into three dimensions, it will likely also fail as interior architecture. The error here was in the process; it was too rigid, too final, too random, and explored too few options. This solution ignored several principles described throughout this book, some of which are noted on the plan.

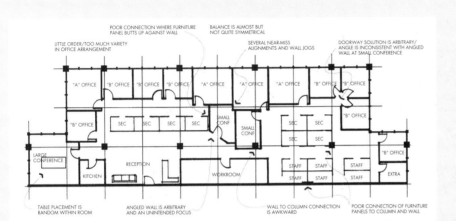

This second study, on the other hand, was driven by conceptual thinking—by ideas—but possibly at the expense of function. Although interesting, it appears inefficient, and it may be impractical when brought into three dimensions. The suggestion here—at least for the beginner—is to allow conceptual ideas to be subtle or even nonexistent in the space plan; instead, consider developing these ideas in the three-dimensional articulation of the plan, in its details, or in the selection of colors and materials.

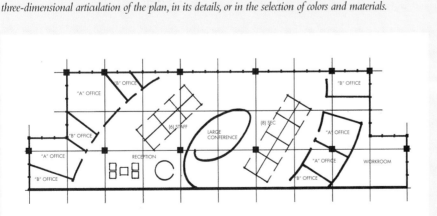

This third sketch, an example of a "bubble" or schematic diagram, demonstrates a better strategy for beginning the space-layout process. It was arrived at by sketching quickly and loosely, and by looking at many ideas before committing to any one. It was actually a culmination of several studies, each refined from (or suggested by) the one previous. These studies are approximately, but not accurately, drawn to scale. More importantly, they address both function and composition.

From this rougher sketch, the designer developed a more articulated version of the plan, below. At first glance, this solution may appear unimaginative or uninteresting—too "clean," and possibly too symmetrical. Yet the authors suggest that it is an appropriate solution given the parameters of the problem, and that it still allows for conceptually innovative development of the plan in three dimensions. (It is often easier to add variety—or interest—to a more unified plan than to bring order to an overly complex plan. Take a look at award-winning or published interior design; most of these projects become "interesting" when articulated three-dimensionally, in details, color and materials. The plans themselves, although they work compositionally, are often more straightforward.)

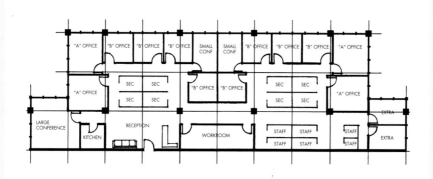

And yet something else is not working here. Look closely at the building grid (shown in black). The architecture is constructed based on a 30 ft. (9m) column grid with window mullions (dividers) spaced at 5 ft. (1.5m) intervals. Space requirements defined by the client include offices at 14 ft. × 16 ft. (4.2m × 4.8m) and 12 ft. × 12 ft. (3.6m × 3.6m) (grid shown in red). Not only will these sizes fight the building grid (especially when developed later with modular ceiling systems, lighting, etc.), but new interior walls crash into glass at the building perimeter (a poor connection not readily apparent in a space plan). The designer has a responsibility to carefully consider context and to design across scale; interior design can succeed only when its architectural context is understood as part of the problem. Sometimes the designer has no choice but to marry inconsistent modules, but in this case these off-module dimensions are challengeable.

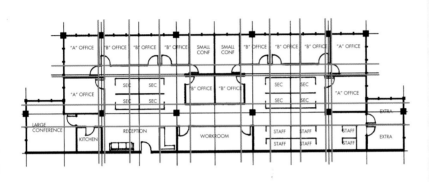

Thus, a modified solution was developed which better respected the building context, below. Office sizes of 15 ft. × 15 ft. (4.5cm × 4.5cm) and 10 ft. × 15 ft. (3m × 4.5m) closely approximated the given office sizes and related much better to the building grid. The configuration of offices and secretarial stations began to work well. Yet the remaining space at the bottom of the plan (colored overlay) was not well proportioned relative to the functions (reception, workroom, etc.) that needed to occupy it.

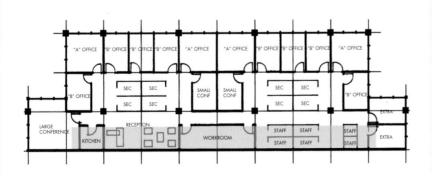

A new but similar solution was explored which shifted the primary circulation path and allowed for a better fit of the reception and workroom spaces. We note, however, that the linear rhythm of secretarial workstations is somewhat jarring against the long wall of private offices; openings and doorways fail to relate to each other in a way that feels "designed." The circulation space around these workstations may also be excessive, and the two end offices are somewhat undersized. So, a variation on this solution was suggested.

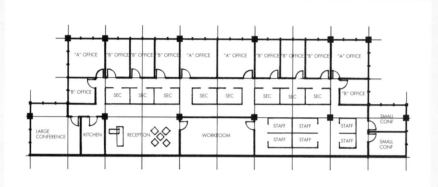

By turning several of the 10 ft. × 15 ft. (3m × 4.5m) offices sideways, a new, and likely improved, version of the plan was created. Once again, this solution does not appear at first glance to be particularly innovative or creative, but we suggest that it is appropriate to the problem and to its context, and that it can be easily translated into exciting three-dimensional interior architecture.

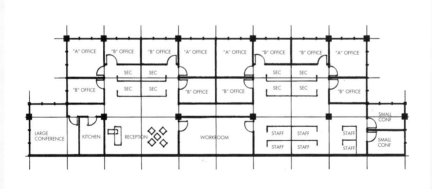

Although it may not be necessary, we note that if the designer wishes to add interest to the space plan, this can happen in many creative ways which still respect the functionality and the compositional clarity that have already been developed. Here the previous study is modified by simply changing the shape of the circulation corridor.

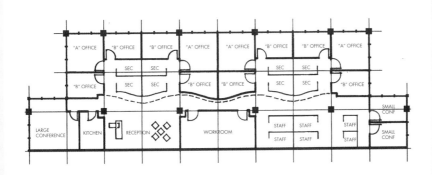

Or the designer may wish to acknowledge the asymmetrically located entry and add greater variety, now that unity has been achieved.

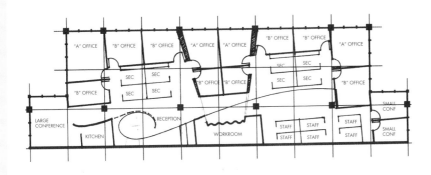

As a final thought, a reminder that the design process continues down to the smallest scale. The same rigor—and respect for design principles—must be applied to the design of a conference space, or to the design of a custom wall light.

case study 3

Problem: Create a creamer as part of a series of prototypes in silver for the new American market. Emphasize the economy of form, materials and labor, while focusing on expression of form. The final pieces should be easily reproducible through simple hand techniques.

Research: With this problem, the designer studied the typology, or tradition, of the creamer. Why is a creamer shaped the way it is? Why do we recognize this shape and distinguish it from other pieces of table service? What are the clues to its function? How can the designer abstract the form while still maintaining these clues?

Design Exploration: The designer began exploration with a few small sketches, but moved almost immediately into three-dimensions with paper models. The models express the form more clearly than two-dimensional sketches. Functional considerations become more apparent, and can be more rapidly developed and refined.

The models to the right were early explorations of form. They were initially influenced by some previous pieces. The designer was carefully studying the relationship of body to handle and spout. The form seems heavy in how it sits on the ground, and possibly also because of its stout proportion.

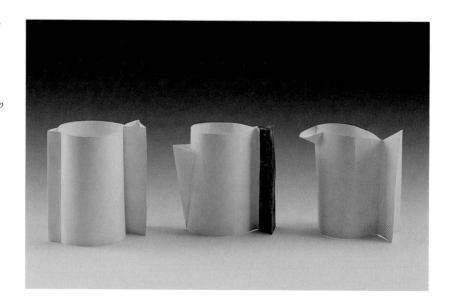

The designer decided to explore a taller and more conical shape. The cone shape, wider at the bottom and narrower at the top, lightened the form and appeared more elegant. By changing the shape, the posture of the object became more important. The designer tried various angles, above, and thought carefully about how the object connected with the table. It was also important to achieve an asymmetrical balance when the creamer was viewed in profile. Each part serves to counter the others in achieving this visual balance. At this point, the designer experimented with various surface textures, right. This idea would resurface later.

A more refined model was created. The metaphorical associations with bird, angel, or butterfly were becoming apparent. The designer was now ready to experiment with the form in metal.

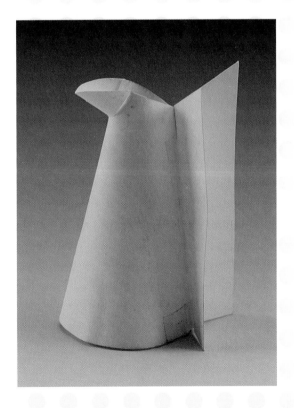

Design Refinement: Following these initial explorations, the designer contin-
ued to refine the form. At this point it was important to study the materiality of
the object, to make sure the shapes could be constructed easily in metal, and
to further understand how the material would affect the aesthetic of the form.

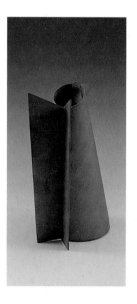 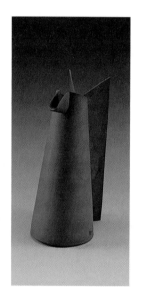 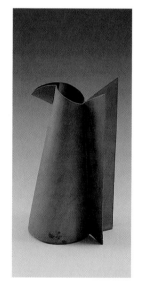

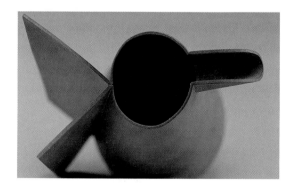

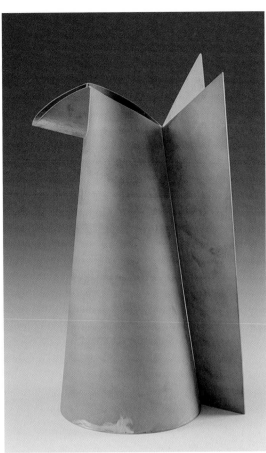

The precise angle of cut in spout, body and handle were further refined. Viewed together, these lines define negative space that becomes an equally important consideration in the design. These lines further strengthen contrast in the piece through juxtaposition of angular and rounded shape.

As the shapes became more dynamic, the "winged creamer" became more animated and expressive, further acknowledging the metaphors of bird, angel and butterfly.

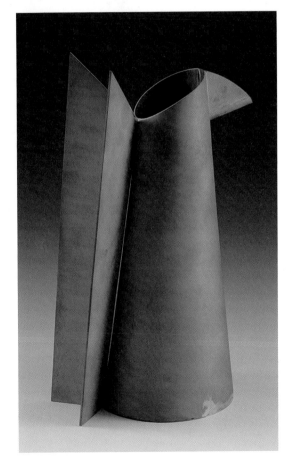

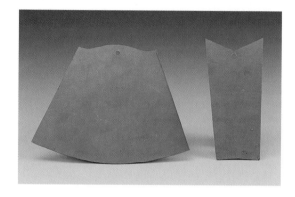

The design was carefully evaluated against the problem as given. The creamer was to be reproducible using simple hand techniques. This solution could be constructed using only two pieces of metal, above, that could easily be shaped into the final form.

The creamer was evaluated alongside a matching pitcher, far left. The pitcher is larger but holds proportional relationships.

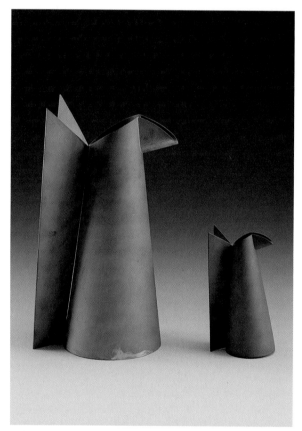

The final texture on the surface of the piece was inspired by a discarded paper cup. The ordinary becomes extraordinary in a different application.

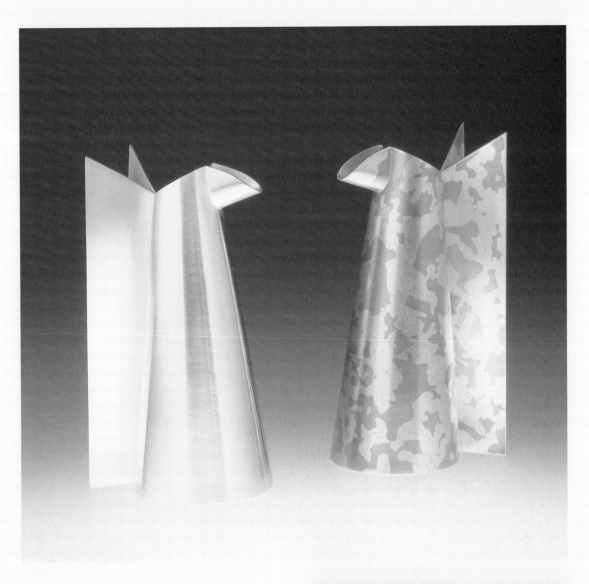

The creamer is shown here in final form, above. A matching
pitcher and sugar bowl are shown at right. Again, each is
designed as part of a series, and each must continually be
evaluated within the context of the entire series.

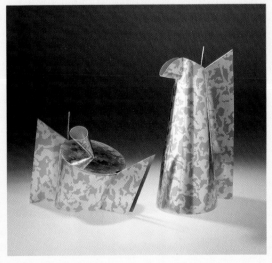

case study 4

Problem: In this exercise, we "deconstruct" the façade of a single-family house and then reconstruct it in a series of steps to show how the designer might think about its composition based on principles discussed throughout the book. Even though this problem is architectural, and essentially three-dimensional, we present it here as more of a two-dimensional study (again recognizing the format in which these images are communicated). More typically, design process would be documented through a series of rough sketches and three-dimensional models. As always, there are an infinite number of valid design solutions; yet any single approach can continually be refined through a rigorous process of assessment, modification and reassessment. This is what is illustrated here.

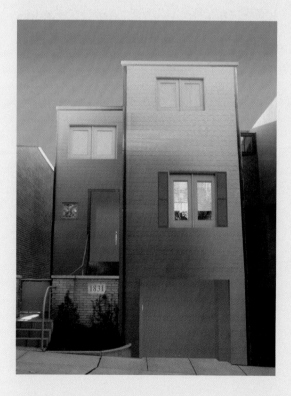

In this first image, both the building form and the composition of the façade must be carefully evaluated within the context of the neighborhood. What are the characteristics of adjacent buildings? In addition, both building form and façade are derived from and help to determine the interior spatial layout. This initial study (as well as all subsequent studies) must be continually evaluated both within a context and as a context through a process that moves fluidly across scale. Given this, we focus more specifically on the compositional qualities of the building façade.

While this initial solution may respond well to functional and contextual constraints, it is perhaps too unified as a visual composition. It lacks interest and a controlled complexity. More specifically, we cite four concerns: a lack of visual contrast; an unintended focus created by the small window; an unresolved condition where the building meets the sky, and the arbitrary use of window shutters.

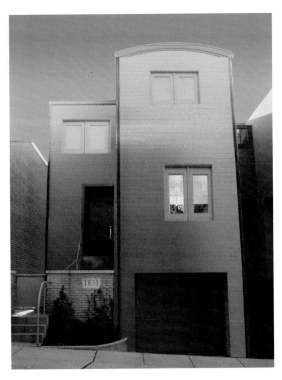

We attempt to address these concerns by adding contrast in the entry door and garage door, removing the small window (again, this must be evaluated against functional requirements), modifying the roofline, and deleting the shutters. These moves seem to improve the composition. However, we now notice a lack of any hierarchy in the selection of window sizes. Just as interior functions will likely dictate differing window sizes, greater size variety will also improve the composition of the façade by allowing the eye to move from areas of greater to lesser importance. A second observation is that a center alignment is implied by the placement of both the upper windows and the garage door in the larger volume. The slight misalignment of the taller windows suggests that they should either be shifted to the left to align or shifted further to the right to strengthen an asymmetrical balance in the composition. As is, their placement is ambiguous.

In this image, different window sizes create a much more pleasing hierarchy and a better relationship with functional requirements. (Note that by grouping individual windows within a common ground, they are read as a single element in the composition.) Yet we wonder if an even greater level of contrast in window sizes might improve the composition further.

This seems to. Not only is the window size contrast increased, but we identify two other modifications that help to improve the visual composition. First, the upper railing adds a much needed level of detail that increases the scalar range. Second, by pulling the large window mass several inches away from the wall, this element is more clearly defined. A different kind of hierarchy is now visible in the multiple layers that move from foreground to background. And by creating some three-dimensional relief in the façade, the designer begins to exploit the dynamic qualities of natural light. (The authors note that much architecture suffers because it is too flat; it fails to take advantage of light and shadow as design elements. While the two-dimensional composition of the façade may be studied on paper, it is ultimately three-dimensional when constructed.)

In this image, the roofline is again modified in an effort to further unify the composition. The partial outline created by the roof aligns with the large window mass and ties it together with the upper windows. Also, we reintroduce the small window that we initially removed. As the level of contrast has been increased, the smaller window may now add to, rather than detract from, the composition.

As the level of hierarchy is improved relative to both window sizes and three-dimensional relief, we now wonder if a greater range of color/value contrast might also improve the composition. We try adding color to the large window mass. This might work. It also recognizes the importance of this window as a visual focus relative to the garage door.

In this image, we modify the design in several places through the articulation of detail. Remember, while the photographs in this section hold viewing distance constant, the building is actually experienced at multiple scales. Here, the large window, garage door, entry door and gate are articulated consistently with a square geometry that mirrors the small windows and helps to unify the composition. The arc added above the gate replicates the roof curve. And a medallion is added above the upper window. Also note the addition of cornice trim. This further helps the transition from building to sky and acknowledges the different condition that exists at the top of the wall. The authors suggest that the improvement in this image from that proceeding, while subtle, is significant. When the design is explored solely at one scale, it can only succeed at that scale and will likely fail at other scales.

Two additional modifications are made in this image. First, the brick used in the privacy wall replaces wood siding around the garage in an effort to better ground the building to its site, and to better relate the privacy wall to the building itself. Second, the steel structure required above the garage is expressed rather than concealed. We like both revisions, but note an unintended visual focus created by these design moves. The stone coping above the brick creates a strong horizontal line across the composition that crosses at ninety degrees to the equally strong vertical line created by the left downspout. The point of intersection is not deserving of its visual prominence.

So the line of the brick is moved higher. This seems better but somehow also divides the composition uncomfortably into two halves. What if the brick is raised higher only at the window mass?

This seems to work! The brick and wood siding now lock into each other. And the brick, by serving as a common ground for both the large window mass and the garage, anchors both to each other and to the ground.

We continue the process by further exploring color in the window mass and by (once again) studying the composition without the small window. These may or may not be improvements. Note that the additional color studies, below left and middle, do not take the design in a good direction. Nor do the foreign design details, below right, add to the clarity of the solution. This may be a good place to quit! Compare the image above with where we started. It is not radical or unusually creative, but it is, we would argue, a strong and appropriate design solution.

IMAGE LIST & CREDITS

Cover
Dandelion: Nature's Graphics CD, Comstock Royalty-free
"Bullseye Teapot": © Susan Ewing, 1989, artist; MCIS photography
"FGM Offices": © Hedrich Blessing, Ltd., photography
"L'Intransigeant" poster: A.M. Cassandre, 1925, designer; © Reinhold Brown Gallery
Paley Park, New York: © Jinbae Park, photographer
Newport Aquarium, detail, Newport, KY: © John Weigand, 2002, photographer

Half title page
"Serie Arquitectonica: Broken Grille Pendant": © Susan Ewing, 1986, artist; MCIS photography

Full title spread
Italian window, Florence, Italy: © Peg Faimon, 1994, photographer
"OBOR 1: Tea and Coffee Set": © Susan Ewing, 1995, artist; MCIS photography; production by Argenteria Gabiele DeVecchi, Milan, Italy
Bridge, Columbus, IN: © John Weigand, 2002, photographer
Futon detail: Miami University student work, Greg Warner, 1994, designer; MCIS photography
Kerquelen Shoe Store, Soho, New York, NY: © Jinbae Park, photographer
Blue door, Pochampally, India: ©Krishna Joshi, 1998, photographer

Acknowledgments spread
Portrait of Peg Faimon: © MCIS photography, 2003
Portrait of John Weigand: © MCIS photography, 2000
Miami University graphic, detail: © Thomas Effler, designer
House, Cincinnati, OH: © John Weigand, 2002, photographer
Train: © Thomas Effler, designer
Bergdorf & Goodman Store Window (NYC): © Jinbae Park, photographer

Table of contents spread
"Farnsworth House": © Hedrich Blessing, Ltd., photography
"Christy" Bowls: Christopher Dresser, designer; © Alessi/FAO
"Sedmé Nebe (Seventh Heaven)" poster, detail: ©Zdenek Ziegler, designer
Yellow chair, Luminaire, Chicago, IL: © John Weigand, 2003, photographer
"Systema Colour as an Art Form", detail: © April Greiman, designer

1 Introduction
P. 8 Sunflower: Nature's Graphics CD, Comstock Royalty-free
 Shaker doors, Shaker Village, Pleasant Hill, KY: © Peg Faimon, 1996, photographer
 Bed detail: Miami University student work, Jared Coffin, 1994, designer; MCIS photography
P. 9 "Arts at Miami" magazine cover: © Peg Faimon, designer; hand image by Ellen Price
P. 10 "Dr. Kiss" toothbrushes: Philippe Starck, 1998, designer, Alessi/FAO; © Jinbae Park, photographer
P. 11 Swiss woodpile, Mürren, Switzerland: © Peg Faimon, 1993, photographer
 "Blade Teapot": © Susan Ewing, 1995, artist; MCIS photography

2 Elements
P. 12 Italian pottery, Gracia Factory, Italy: © Peg Faimon, 2001, photography
 Millennium Series logo: © Peg Faimon, 1999, designer
P. 13 Trees: Nature's Graphics CD, Comstock Royalty-free
 Table: Miami University student work, Anna Yahl, 1995, designer; MCIS photography
 "Inner Circle Teapot": © Susan Ewing, 1991, artist; MCIS photography
P. 14 Nude: Photo used courtesy of Robert Farber ©, photographer, from his book, *Classic Farber Nudes*, pg. 52
P. 15 Bending tree, France: © Peg Faimon, 1993, photography
 Flamingo: Animals/Wildlife CD, Comstock Royalty-free
 Hill: © John Weigand, 2002, photography
 Chair: © John Weigand, designer; MCIS photography
 Guitar: © Geoff Eacker, designer; MCIS photography

Door, Milan, Italy: © Peg Faimon, 1999, photographer
P. 16 Floorplan: © John Weigand, 2002, designer
 Waves logo: © Peg Faimon, 2002, designer
 Pin: © John Weigand, 2000, designer; MCIS photography
P. 17 Ponte Vecchio, Florence, Italy: © Peg Faimon, 1994, photographer
P. 18 Teapot: © Susan Ewing, 1981, artist; MCIS photography; John Weigand, photomanipulations
P. 19 Yellow house, Vernazza, Italy: © Paul Owens, 2000, photographer
 "Flowers of the World," New York, NY: © Jinbae Park, photographer
 St. Peter's, Rome, Italy: © Paul Owens, 2000, photographer
 Scent packaging: Miami University student work, Tsui Yee Wong, designer
 Pedestrian walkway, Zurich Switzerland, Santiago Calatrava, architect: © Paul Owens, 2000, photographer
P. 20 Collage: © Five Visual Communication & Design, designer
 Merlot, New York, NY, Jordan Moser: © Jinbae Park, photographer
 Metal Wall: © John Weigand, 2002, photographer
Pp. 21, 22 Skyline and River, Chicago, Illnois: © John Weigand, photographer and photomanipulations
Pp. 14–17 Line graphics: © Peg Faimon, 2003, designer

3 Principles
P. 24 Striped dress: University of Cincinnati student work; Grace Meacham, Phyllis Borcherding, instructors
 Column: © John Weigand, 2002, photographer
P. 25 Spider web: Nature's Graphics CD, Comstock Royalty-free
 Fence, Santa Fe, New Mexico: © John Weigand, 2002, photographer

3.1 Unity & Variety
P. 27 Red flower: Nature's Graphics CD, Comstock Royalty-free
P. 28 Signage, Cincinnati, Ohio: © John Weigand, 2002, photographer
 Windows: © John Weigand, photo manipulation
 Interior: © John Weigand, 2003, photographer
P. 29 Housing: © John Weigand, 2002, photographer
 Yellow pages ad: © Peg Faimon, 2002
 Red outfit: © MCIS photography; Marita Spenser, model
P. 30 Poster exhibition, Interlaken, Switzerland: © Peg Faimon, 1993, photographer
 Fashion sketches: University of Cincinnati student work, Elizabeth Post, designer
 Houses, Burano, Italy: © Peg Faimon, 1999, photographer
P. 31 "Douglas W. Schmidt" poster: © April Greiman, designer
 UFA Cinema Center Interior Stair, Dresden, Germany: Coop Himmelblau; © John Reynolds, 2001, photographer
 "E Squared & Portraits/Elliott": © Hedrich Blessing, Ltd., photography
 "Yamamoto Residence": © Hedrich Blessing, Ltd., photography
P. 32 Nevsky posters, © Peg Faimon, 2002
P. 33 Housing, Amsterdam, Netherlands: © John Weigand, photo-manipulations
 Housing, Amsterdam, Netherlands: © Michael Uhlenhake, photographer
P. 34 "Arts at Miami" magazine: © Peg Faimon, 2002, designer
P. 35 Klagenfurt 2006 Olympic bid symbol system/pictograms: © Iconologic, designers
 TierOne Bank photocollages: ©TierOne Bank, Monigle Associates, designers

3.2 Grouping
P. 37 Moraine Lake, British Columbia, Canada: © Peg Faimon, photographer
P. 38 Bauhaus Museum, Berlin, Germany: © Peg Faimon, photographer
 "Road Trip to Miami" CD packaging: © Miami University Center for Interactive Media Studies, Sarah Hemp and Joanne Easton, designers, 2003
 Landscape: © John Weigand, 2002, photographer
 Graphics: © Peg Faimon, 2003, designer
P. 39 "Alonzo Table and Mirror": © Ron Pretzer/Luxe, photographer

"OBOR Flatware": © Susan Ewing, 1986, 1990, artist; MCIS photography

"Nokia": © Hedrich Blessing, Ltd., photography

Hyatt Hotel, Fukuoka, Japan: © Jinbae Park, photographer

Stair addition, University of Washington, Seattle, Washington: © John Weigand, photographer

P. 40 Townsquare, Landsburg, Germany: © Peg Faimon, 1993, photographer

Giorgio Armani, Las Vegas, NV: © Jinbae Park, photographer

SKC logo: © Peg Faimon, 1988, designer

Grouping progression: © John Weigand, 2003

P. 41 Skyline, Seattle, Washington: © Peg Faimon, 1996, photography

"Miami Made" exhibition brochure: © Peg Faimon, 2000, designer

Luminaire interior, Chicago, Illinois: © John Weigand, 2003, photographer

P. 42 Salon interior, Cincinnati, Ohio, BHDP Architecture/Ann Weigand, designer: © John Weigand, 2003, photographer

Trees: © John Weigand, 2002, photographer

Shriver Center, Oxford, Ohio: © John Weigand, 2002, photographer

Plate of food, Alexander House, Oxford, OH: © MCIS photography

Arts logo: © Peg Faimon, designer

P. 43 Anger Castle Garden, Anger, France: © Peg Faimon, 1993, photographer

Clock face: Miami University student work, Jill Annarino, designer, 1992

House and fence, Williamsburg, Virginia: © John Weigand, 1994, photographer

P. 44 Architectural detail, Prague, Czech Republic: © Peg Faimon, 1993, photographer

P. 45 "Remembering Chicken Little," Quilt: © Jan Myers-Newbury, 1981, designer

Christmas card collage: © Peg Faimon, designer; illustration by Christopher Hickey

Taft Museum of Art web site: © Taft Museum of Art, 2001; Center for Interactive Media Studies, Adam Arriola, Rebecca Shur, and Jill Krueger, designers

P. 46 Coat, hat, and backpack Set: University of Cincinnati student work; Grace Meacham, Phyllis Borcherding, instructors

Arts logo: © Peg Faimon, photomanipulation

Plate: © John Weigand, photomanipulation

P. 47 Mosque, Cairo, Egypt: © Paul Owens, 2000, photographer

3.3 Rhythm & Pattern

P. 48 Beehive, Cactus, Snakeskin: Nature's Graphics CD, Comstock Royalty-free

P. 49 Peacock: Animals/Wildlife CD, Comstock Royalty-free

Graphic: © Peg Faimon, 2003, designer

Pp. 50, 51 Movie theatre detail, Celebration, Florida: © Peg Faimon, 1998, photographer; John Weigand, photomanipulations

Poster: © Peg Faimon, designer and manipulations

Interior: © John Weigand, photographer and photomanipulations

P. 52 Interior, Cranbrook Academy, Michigan: © John Weigand, photographer

Doge's Palace, Venice, Italy: © John Weigand, 1999, photographer

Music: © Robert Benson, 2003

P. 53 Rhythm graphic: © Peg Faimon, designer

Floorplan: © John Weigand

P. 54 Kente Cloth, Ewe region, Ghana, West Africa: © Peg Faimon, 2003, photographer

Plates from street market, Pisac, Peru: © Paul Owens, 2000, photographer

P. 55 Gate, Peggy Guggenheim Museum, Venice, Italy: © Peg Faimon, 1999, photographer

Architex fabric: © John Weigand, photographer

Pattern graphic: © Peg Faimon, designer

P. 56 Gate, fabric, and graphic manipulations: © John Weigand, photomanipulation

P. 57 Chairs, Celebration, Florida: © Peg Faimon, 1998, photographer; John Weigand, photomanipulation

House, Kinsale, Ireland: © Peg Faimon, 1993, photographer; John Weigand, photomanipulation

Church door, Cuzco, Peru: © Paul Owens, 2000, photographer; John Weigand, photomanipulation

P. 58 Pattern and texture: © John Weigand

Door, Pisa, Italy: © Peg Faimon, 1994, photographer

P. 59 Quilt detail: © Charly Fowler, photographer

Machu Pichu, Peru: © Paul Owens, 2000, photographer

"Snow White + the Seven Pixels" poster: © April Greiman, designer

Green dress: University of Cincinnati student work; Grace Meacham, Phyllis Borcherding, instructors

Window, Pitti Palace, Florence, Italy: © John Weigand, 1999, photographer

Garlic: Miami University student work, Devon Hoernschemeyer, 2000, designer

Pp. 60, 61 Patterns: © John Weigand

P. 61 Chair and rug: © John Weigand, 2002, photographer

Pattern graphic: © Peg Faimon

Pattern outfit: © MCIS photography, 2002; Marita Spenser, model

3.4 Connection

P. 63 Red flower, Nature's Graphics CD, Comstock Royalty-free

P. 64 Material connection: © John Weigand, 2002, photographer

P. 65 Coat and hat: University of Cincinnati student work; Grace Meacham, Phyllis Borcherding, instructors

Petronas Towers, Kuala Lumpur, Malaysia, Cesar Pelli, architect: © Paul Owens, 2000, photographer

Bookcase: Miami University student work, Ted Christian, 1994, designer

P. 66 Interior design poster: © Molly Schoenhoff, designer

Building entrance, Kinsale, Ireland: © Peg Faimon, 1993, photographer

Earrings: © John Weigand, 2000, designer, MCIS photography

P. 67 Table: Miami University student work, Casey Blum, 1994, designer

Columns, Assisi, Italy: © Peg Faimon, 1999, photographer

Point-of-Sale display: © John Weigand, 2003, photographer

P. 68 Porch, Seaside, Florida: © John Weigand, photographer

Indiana University Art Museum, Bloomington, Indiana: © John Weigand, photographer

Barn: © John Weigand, 2002, photographer

Suburban house: © John Weigand, 2003, photographer

P. 69 Empress Hotel, Victoria, British Columbia, Canada: © Peg Faimon, 1996, photographer; John Weigand, photomanipulations

P. 70 Indian Ridge Golf Club logo: © Peg Faimon, 1999, designer

Le Corbusier House, Zurich, Switzerland: © Peg Faimon, 1995, photographer

Bedside table: © John Weigand, 1995, designer; MCIS photography

Newport Aquarium detail, Newport, Kentucky: © John Weigand, 2002, photographer

P. 71 Dresser: Miami University student work, Jeff Warner, 1999, designer

IBM poster: © Peg Faimon, 1985, designer

Cathedral, Bath, England: © Peg Faimon, 1995, photographer

P. 72 Design logo: © Peg Faimon

House detail: © John Weigand, photographer

Table: Miami University student work

Columns, Celebration, Florida: © Peg Faimon, 1998, photographer

House: © John Weigand, 2002, photographer and photomanipulations

P. 73 Dessert plate: © John Weigand, 2002, photographer

3.5. Contrast

P. 75 Frog, Animals/Wildlife CD, Comstock Royalty-free

P. 76 Graphics: © Peg Faimon, 2003, designer

P. 77 UFA Cinema Center, exterior, Dresden, Germany: Coop Himmelblau; © John Reynolds, 2001, photographer

Visual Marketing Associates web site: © VMA, inc., 2003

Door pulls, Cincinnati, OH: © John Weigand, photographer

"Svedená a Opustena" poster: © Zdenek Ziegler, 1965, designer

"Villa Belle": © Hedrich Blessing, Ltd., photography

P. 78 Butterfly spread: © Art Technology Group, 2002; Tank Design, designers

Paramount Hotel lobby, New York, New York: © Jinbae Park, photographer

Pp. 79, 80 Paramount Hotel lobby manipulations: © John Weigand, photomanipulations

P. 81 Aronoff Center for the Arts, detail, Cincinnati, Ohio: © John Weigand, 2003, photographer

Shoreham Hotel, New York, NY: © Jinbae Park, photographer

Carbone Smolan Agency stationery: © Carbone Smolan Agency, designers

P. 82 RMW web site: © RMW, Leonhardt:Fitch, designers

Signage, Chicago, IL: © John Weigand, 2003, photographer

Block printed fabric from Kutzh, India: © Peg Faimon, 2003, photographer

House, Taos, NM: © John Weigand, 2003, photographer

P. 83 Woodpile, Murren, Switzerland: © Peg Faimon, 1993, photographer

P. 84 House, Seaside, Florida: © John Weigand, photographer

Firefly Building entrance: © VMA, inc., 2002

P. 85 House, Seaside, Florida: © John Weigand, photographer and photomanipulation

Flamingo: © John Weigand

Garage addition: © John Weigand

P. 86 Hueston Woods Lodge, Oxford, OH: © Peg Faimon, 2003, photographer

Tower and Parks Project logo, © Peg Faimon

Door, Venice, Italy: © John Weigand, photographer

P. 87 Street signage, Cincinnati, Ohio: © John Weigand, photographer

Airport signage, Cincinnati, OH: © John Weigand, photographer

Seaside Momochi, Fukuoka, Japan: © Jinbae Park, photographer

P. 88 Herman Miller Showroom, Merchandise Mart, Chicago, Illinois: © John Weigand, photographer

P. 89 Cincinnati Ballet brochure: © VMA, inc., designers

P. 90 Hierarchy graphics: © Peg Faimon, designer

P. 91 Cincinnati Ballet poster: VMA, inc. designers

3.6 Context & Scale

Pp. 92, 93 Redbud series: © John Weigand, 2002, photographer

P. 94 100% Make up Vases, Alessi/FAO Factory, Orta, Italy: © Peg Faimon, 2001, photographer

Architectural model: Miami University student work, Kurt Zobrist, designer

Empress Hotel ceiling: © Peg Faimon, 1996, photographer

P. 95 Gold Star restaurant: © John Weigand, photographer

House and detail: © Peg Faimon, photographer

Banner and context: © Peg Faimon, designer and photographer

P. 96 Pinecote Pavilion: Fay Jones, architect; © Timothy Hursley, photographer

P. 97 Health and Spa Facilities, exterior, Bad Elster: Behnisch & Partner; © John Reynolds, 2000, photographer

Health and Spa Facilities, interior, Bad Elster: Behnisch & Partner; © John Reynolds, 2000, photographer

Palazzo Vecchio Bell Tower, Florence, Italy: © Peg Faimon, 2001, photographer

Church, Bay View, Michigan: © Peg Faimon, 1995, photographer

Warner Brothers, New York, NY: © Jinbae Park, photographer

P. 99 VMA business card: © VMA, inc.

P. 100 Fashion design: University of Cincinnati student work; Grace Meacham, Phyllis Borcherding, instructors

Out-of-scale chair: © John Weigand, photomanipulation; Marita Spenser, model

Out-of-scale toothbrush: © John Weigand, photomanipulation

P. 101 Colorful house, Burano, Italy: © John Weigand, 1999, photographer

3.7 Balance

P. 103 Elephant: Animals/Wildlife CD, Comstock Royalty-free

P. 105 Villa Rotunda, Italy: © John Weigand, 2001, photographer

Door and window, Orta, Italy: © Peg Faimon, 2001, photographer

P. 106 Italian Design poster: © Peg Faimon, 2000, designer

P. 107 Vontz Center, Cincinnati, OH: Frank Gehry and BHDP Architecture; © John Weigand, photographer

Vontz Center floorplan: © Frank Gehry and BHDP Architecture

Chapel, Florence, Italy: © Peg Faimon, photographer

Face: © MCIS photography; Craig Rouse, model; John Weigand, photomanipulations

P. 108 Graphics: © Peg Faimon, 2003, designer

P. 109 House, Chicago, Illinois: © John Weigand, photographer

House, Cincinnati, Ohio: © John Weigand, photographer

"Collezione Bauhaus," Tea Infuser: © Alessi/FAO

P. 110 Design Shop logo: Miami University student work, Danielle Kim, designer

House, Burano, Italy: © John Weigand, photographer

"Image + Text" exhibition poster: © Peg Faimon, designer

Pp. 112, 113 Computer Model: Miami University student work, Terry McCormick, designer

P. 114 "Fleurs de Fete" poster: © VMA, inc., 2000, designers; John Weigand, photomanipulation

P. 115 Louvre addition, Paris, France: I.M. Pei, architect; © Peg Faimon, 1993, photographer; John Weigand, photomanipulation

P. 116 Kilpatrick Stockton LLP recruiting brochure: © Kilpatrick Stockton, Iconologic, designers

P. 118 Lifespan logo: © Five Visual Communication & Design, designer

Catholic Social Services logo: © Five Visual Communication & Design, designer

P. 119 Paley Park, New York, New York: © Jinbae Park, photographer

3.8 Placement

P. 121 Pelicans: Animals/Wildlife CD, Comstock Royalty-free

Sunset, Ludington, Michigan: © Peg Faimon, 1982, photographer

"Farnsworth House," Plano, IL: Mies van der Rohe, architect; Hedrich Blessing, Ltd., photography

Trees and mountains: © Peg Faimon, photographer

Florence, Italy: © John Weigand, photographer

Tree and stream, Ireland: © Peg Faimon, photographer

Indiana University Foundation, Bloomington, Indiana: © John Weigand, 2002, photographer

P. 122 "OBOR 2": © Susan Ewing, 1990, artist and photographer; John Weigand, photomanipulation

Graphics: © Peg Faimon, designer

P. 123 Graphic: © Peg Faimon, designer

Conference room: © John Weigand, photographer

Art Building, Miami University, Oxford, OH: © Peg Faimon, photographer

P. 124 Santa Maria Novella, Florence, Italy: © John Weigand, photographer

P. 125 "Isadora Duncan" poster: © Zdenek Ziegler, designer

Window detail: © John Weigand, 2002, photographer

P. 126 Interior Design presentation: Miami University student work

House, Cincinnati, Ohio: © John Weigand, photographer and photomanipulations

P. 127 Tudor house, Cincinnati, Ohio: © John Weigand, photographer

University Hall floorplan, University of Cincinnati, Cincinnati, OH: © VOA Associates and BHDP Architecture

Niketown display, Chicago, Illinois: © Peg Faimon, photographer

P. 128 Graphics: © Peg Faimon, 2003, designer

P. 129 "Wilhelm Tell" poster: © Armin Hofmann, 1963, designer

3.9. Proportion

P. 131 Nautilus Shell: Nature's Graphics, Comstock Royalty-free

P. 132 Garage: © John Weigand, photomanipulation

Business Card: © Peg Faimon, manipulation

Column: © John Weigand, photomanipulation

Garage, card, and column graphics: © Faimon and Weigand

P. 133 House, Williamsburg, Virginia: © John Weigand, photographer

Vaud Farm House, Ballenburg Open Air Museum, Brienz, Switzerland: © Peg Faimon, 1993, photographer

P. 134 Hallway/room: © John Weigand, photomanipulation

P. 135 Nautilus shell: © John Weigand, photomanipulation

Owl: © John Weigand, photomanipulation

P. 136 Parthenon, Athens, Greece: © Paul Owens, 2000, photographer; John Weigand, photomanipulation

"The Modern Poster": © April Greiman, designer
P. 137 Santa Maria Novella, Florence, Italy: © John Weigand, photographer and photomanipulation
Miami University Department of Architecture poster: © Peg Faimon, 1992, designer
P. 138 Graphics: © Peg Faimon, 2003, designer
P. 139 "Institut du Monde Arabe" South Façade Panels, Paris, France: Jean Nouvel; © John Reynolds, 1992, photographer
"Institut du Monde Arabe" Interior South Façade Panel, Paris: Jean Nouvel; © John Reynolds, 1992, photographer
P. 140 Housing, Amsterdam, Netherlands: © Michael Uhlenhake
Grid graphic: © Peg Faimon, designer
P. 141 Lettering: © MCIS photography, 2002

3.10 Meaning
P. 143 Tree: Nature's Graphics CD, Comstock Royalty-free
P. 144 Kilpatrick Stockton LLP Recruiting web site: © Kilpatrick Stockton LLP, Iconologic, designers
"Max le chinois" colander: © Alessi, Philippe Starck, 1987, designer
Crayon packaging: Miami University student work, Erin McCabe, 2003, designer
P. 145 Experimental poster: Miami University student work, Michelle Dwyer, 2001, designer
House, Cincinnati, Ohio: Terry Brown, architect; © John Weigand, photographer
P. 146 Computer table, Miami University student work, Alex Shapleigh, 1997, designer
P. 147 Lightbulb packaging: Miami University student work, Julie Seabrook, 2003, designer
"Vessel with Golden Light": © Susan Ewing, 1985, artist; MCIS photography
Townhouses: © John Weigand, 2002, photographer
House: © John Weigand, 2002, photomanipulation
P. 148 Falling Water: © Thomas A. Heinz, 2003, photographer; John Weigand, photomanipulation
P. 149 Glasses from street market, Hong Kong: © Paul Owens, 2000, photographer
P. 150 Victoria house, Bay View, Michigan: © Peg Faimon, photographer
"After Hours": © Daniel Pelavin, 2003, designer/illustrator
P. 151 Country kitchen: © John Weigand, photomanipulation
Trendy fashion: © MCIS photography; Marita Spenser, model
"Tail of the Pup" hotdog stand, California: © John Weigand, photomanipulation
Big Idea logo, © Peg Faimon
P. 152 "Mother & Child" proposed magazine logo, Herbert Lubalin, 1967, designer (Tom Carnase, letterer): © Herbert Lubalin family
"Juicy Salif," Lemon Squeezer and sketch: Philippe Starck, 1990, designer; © Alessi/FAO
P. 153 Ronchamp: Le Corbusier; © Susan Ewing, photographer
Hand graphic: © John Weigand, 2002, designer
Sony Theatre, New York, NY: © Gensler Architecture
Ace Gallery Exhibition, New York, NY: © Jinbae Park, photographer
P. 154 Graphic, Bracelet, Desk, and Chapel: Miami University student work, Bong Sok, 2001, designer
P. 155 "Names Project, AIDS Memorial Quilt," Washington D.C. Mall: © Peg Faimon, 1996, photographer
P. 156 "L'Intransigeant" poster: A.M. Cassandre, 1925, designer; © Reinhold Brown Gallery
Seasonal banners: Miami University student work, Joe Soule, 2000, designer
P. 157 Friends of Fine Arts logo: © Peg Faimon, 2003, designer
"Jsem Proti" poster: © Zdenek Ziegler, 1987, designer
"Anna G." corkscrew: Alessandro Mendini, 1994, designer; © Alessi/FAO
Table: Miami University student work, Darah Purtell
"Diabolix": Biagio Cisotti, designer; © Alessi/FAO
P. 158 Decorated interior: © John Weigand, photomanipulation
Decorated business card: © Peg Faimon
"Krádez Závodních Koní (Horse Theives)" poster: © Zdenek Ziegler, 1979, designer

P. 159 "Serie Arquitectonica: Broken Window Brooches": © Susan Ewing, 1986, artist and photographer
P. 160 Chinese house: © Paul Owens, 2000, photographer
Totum, Vancouver, British Columbia, Canada: © Peg Faimon, 1996, photographer
Figures from Hindu temple, Singapore: © Paul Owens, 2000, photographer
P. 161 Crossroads Café logo: © Peg Faimon
"Requiem" poster: © Armin Hofmann, designer
Oxford Clinic logo: © Peg Faimon, 1997, designer
P. 162 Music for the Millennium logo process: © Peg Faimon, 2000, designer
Architectural process: Miami University student work, Bong Sok, 2001, designer
P. 163 Wall, Florence, Italy: © John Weigand, 1999, photographer
P. 164 Pompidu Center, Paris, France: © Susan Ewing, photographer
Short columns: © John Weigand, 2002, photographer
Mansard roof: © John Weigand, 2002, photographer
Shutters: © John Weigand, 2002, photographer
Materials: © John Weigand, 2002, photographer
P. 165 Matanipachedi technique, Ahmedabad, India: © Krishna Joshi, 1998, photographer
Staircase, Shaker Village, Pleasant Hill, KY: © Hedrich Blessing, Ltd., photography
Computer table, detail, Miami University student work, Alex Shapleigh, 1997, designer
Villandry, French Renaissance gardens: © Peg Faimon, 1993, photographer
P. 166 "Eigen Haard" apartment block, Amsterdam, Netherlands: Michel DeKlerk, architect; © Paul Owens, 2000, photographer
Bauer brochure: © VMA, inc., designers
P. 167 Thistle, Pine Needles, Leaf, Peacock Feather, and Trees: Nature's Graphics CD, Comstock Royalty-free

4 Process
P. 169 Dandelion: Nature's Graphics CD, Comstock Royalty-free
Arts logo, detail: © Peg Faimon, designer
Office floorplan, detail: © John Weigand, designer
Creamer, detail: © Susan Ewing, artist; MCIS photography
Architectural façade, detail: © John Weigand, photomanipulation
Pp. 170–175 Arts logo process and final: © Peg Faimon, designer
Pp. 176–181 Office floorplan process and final: © John Weigand, designer
Pp. 182–187 Creamer process and final: © Susan Ewing, artist; MCIS photography
Pitcher and sugar: © Susan Ewing, artist; MCIS photography
Pp. 188–193 Architectural façade: © John Weigand, photomanipulations

Pp. 26–167
Chapter symbols: © Peg Faimon, 2003, designer

INDEX

More great titles from HOW Design Books!

These books and other fine HOW Design titles are available from your local bookstore, online supplier or by calling 1-800-448-0915.

This book provides you with more than one thousand color combinations and formulas—guaranteed to help you solve your design dilemmas and create effective images for both print and the Web. From progressive colors to natural tones, it makes choosing hues for any job easier and it's all the inspiration you need to explore and experiment with color as never before!

ISBN 1-58180-236-6, paperback w/vinyl cover, 360 pages, #32011-K

Through informative tutorials and illuminating exercises, Bryan Peterson shows you how to express and anchor your concept with the design elements of line, type, shape, texture, balance, contrast, unity, color and value. He also provides examples from some of the world's top designers that show these elements in action.

ISBN 1-58180-425-6, hardcover, 144 pages, #32589-K

This guide provides modern, up-to-date information that puts the power of logo and type creation in your hands. Learn to develop a discerning eye for quality lettering and logo design, create innovative logo design traditionally and on the computer, design custom-made fonts and build a profitable business with logo design work

ISBN 1-58180-436-9, hardcover, 240 pages, #32633-K

This book is a Goliath of ideas with nearly 400 imaginative page design projects, including brochures, posters, CD covers, book jackets, identity systems and more. Insightful captions go "behind the scenes" to reveal the thinking that went into each project.

ISBN 1-58180-444-X, hardcover, 368 pages, #32692-K